The Story of

BABUR

PRINCE, EMPEROR, SAGE

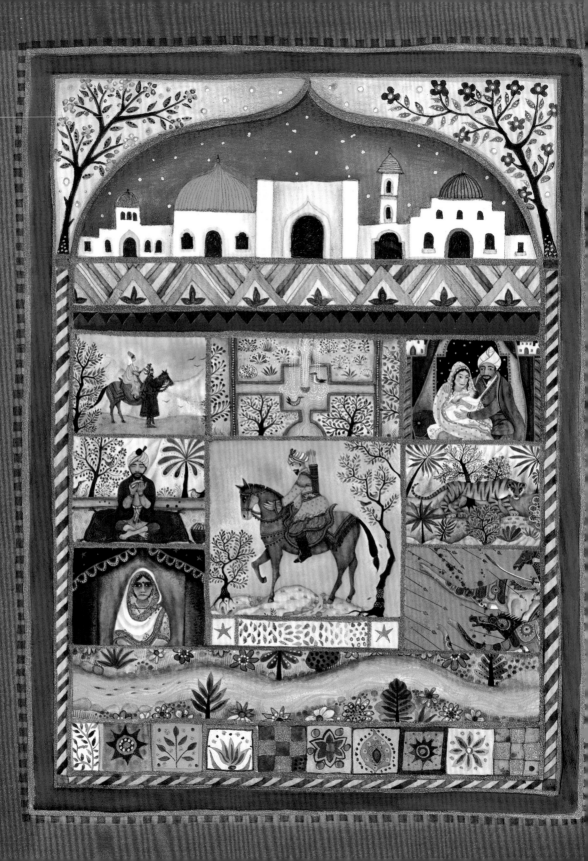

THE
STORY OF
BABUR

PRINCE, EMPEROR, SAGE

THE GREAT EPIC OF CENTRAL ASIA

RETOLD BY ANURADHA
ILLUSTRATIONS BY JANE RAY

For Mummy and Buwa

SCALA

 # CONTENTS

My Dear Reader!

You are holding a special book in your hands. Within its pages, you will find a story about the great and wise ruler Babur from Ferghana, the founder of the Mughal dynasty.

During his extraordinary life, Babur united an empire stretching from present-day India to Afghanistan. But his ruling skills are not the only thing this king is famous for. He also left a rich literary and scientific legacy. His magnificent poems, prose and, most of all, his life story known as the *Baburnama* are a portal to the life of the people of medieval Central Asia.

I invite you to discover the life of Babur and find something unique. What is the most important part of his legacy to you? And who was Babur – a poet, a scientist or a wise ruler who balanced strength and compassion?

Or you can read this book as a tale of adventures full of stories about our rich and diverse land. I hope you will enjoy them as much as generations of readers before you!

Yours truly,

M. Saida

Saida Mirziyoyeva

Deputy Chairwoman of the Council of the Art and Culture Development Foundation of the Republic of Uzbekistan

Map of Central Asia

During Babur's Lifetime

Syr Darya

Djizzak

Bukhara

Samarkand

T R A N S O X I A N A

Amu Darya

This book is set in Central Asia during the lifetime of the mighty king Babur (1483–1530). Some of the places that Babur visited have different names today.

K H U R A S A N

Herat

Ghazni

0 km 200

Kandahar

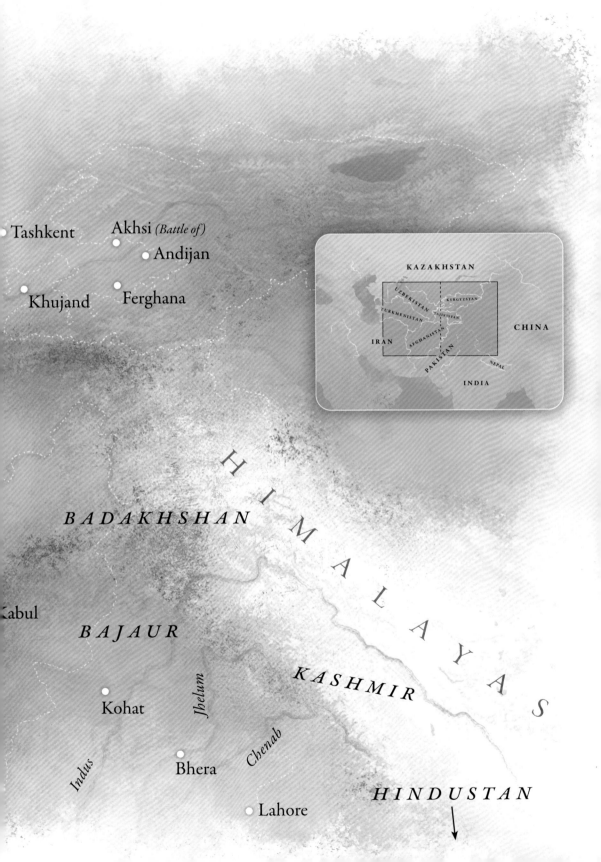

Tashkent

Akhsi *(Battle of)*

Andijan

Khujand

Ferghana

KAZAKHSTAN

UZBEKISTAN

KYRGYZSTAN

TURKMENISTAN

TAJIKISTAN

CHINA

IRAN

AFGHANISTAN

PAKISTAN

NEPAL

INDIA

BADAKHSHAN

H I M A L A Y A S

Kabul

BAJAUR

KASHMIR

Kohat

Jhelum

Chenab

Indus

Bhera

HINDUSTAN

Lahore

1

THE BEGINNING

I am Babur. When I was born, my parents named me Zahir ud-Din Muhammad. I do not exactly know how I came to be known as Babur although that is what everyone calls me now. At the young age of twelve I became king of Ferghana, and at the age of fifteen I ruled two kingdoms. Still, that is not everything. I travelled to many places, fought many battles and became

the first emperor of the famed Mughal dynasty of Hindustan. And this is my story. The story of Zahir ud-Din Muhammad Babur. Hold your horses and prepare to go on a strange yet wonderful journey with me.

The story begins two hundred years before my birth. My great-great-great-grandfather Timur had founded the Timurid dynasty and there were many marvellous towns and cities within the Timurid Empire. As the greatest and finest of them, Samarkand was made the capital.

Many years later, my grandfather ruled this empire. Immediately after his death, the empire was divided among his sons. Each prince became the king of the city and region he was given and ruled over them. My eldest uncle became the king of Samarkand. My

father, my grandfather's third son, became the king of Ferghana. Since the cities were parts of the Timurid Empire, every prince wanted to capture other towns to increase their power. They spent their lives invading each other's lands in the hope of extending their territories and ruling Samarkand. My father was no different. During his lifetime, he led his army against Samarkand several times, but he was always defeated or returned disappointed.

I remember my father as a short man with a round beard and a big smile on his face. He enjoyed a large meal and ordered dish after dish. His stomach was so big that whenever he entered a room, you could see his stomach enter the door before the rest of his body. Because of his stomach, it took him a long time to get ready. To look slimmer, he wore his tunic

tight, and he would hold his breath and pull his stomach in to do up the ties. As he did so, I would tell him a joke and make him laugh. While he laughed, the ties to the tunic would often snap and he would angrily shout at me, '*Shakhzade*!' I would run away laughing.

One of my fondest memories of my father is of us going for a walk to the Sulayman Mountain. I would effortlessly run to the top of the mountain while my father would follow me puffing and panting. We would climb up the mountain and view the entire city of Ferghana. The valley below was full of grain that glittered like gold in the hot bright sun. No wonder Ferghana was called the golden valley. The wide and sunny river ran by the foot of the mountain and the babbling sound of the river was music to the ears. In spring, the

river flowing below had gardens with tulips and roses blooming on either side of its banks. The fruits of Ferghana were equally delicious. Melons, grapes, pomegranates and apples grew in abundance. Even the pheasants of Ferghana were famous. They were so fat that four people could hardly manage to eat the stew cooked from one.

'Ferghana is so beautiful, *ota*,' I would say.

'Yes, my dear *shakhzade*. It is our duty to protect it,' he would reply, looking far off into the horizon. We would sit on top of the mountain eating fruits and my father would tell

me stories, mostly about his childhood days in Samarkand.

'The gardens of Samarkand are magnificent and the pomegranates are the best,' he would remark.

My mother was Qutlugh Nigar Khanim, a direct descendant of Genghis Khan, the famous ruler of the Mongol Empire and one of the mightiest conquerors the world has ever seen. I take great pride in the fact that the blood running in my veins is a mixture of the Timur and the Mongol dynasties.

In those days, kings used to have many wives and so did my father. Apart from my mother, he had two other wives with whom he had three sons and five daughters. We were a big family and we all lived together. I often wondered if my father remembered which one of us children

belonged to which wife. Seniors and elders surrounded my brothers and sisters and me. We had many officers, followers and servants to help us. If you had seen us together, you could have well mistaken us for a small army.

My father had made sure I received the education and training that was suitable for a prince. Bab-Quli, my courtier, trained me in martial arts and other necessary skills. From him, I learnt how to speak, walk and behave like a prince. Similarly, Khwaja Mawlana Qazi was my teacher of religion, tradition and morality. I had great respect for him.

'Remember you are the future king of Ferghana, dear *shakhzade*. You must learn to act like one,' my father would say.

On a warm sunny afternoon, I was playing by the side of a garden pool. A few servants

stood close by. I noticed a messenger come up to them and whisper something. The servants looked shocked.

One of them came running to me and said, 'Hurry up *shakhzade*, we must leave for the fortress.'

On the way to the fortress, a servant told me my dear *ota* had passed away in an accident. When we reached the fortress, one of my father's officers was at the gate to receive me.

As soon as I was inside the fortress, I saw my grandmother. She was busy discussing with officers of my late father about ways to protect me and the town. I ran into her arms and cried.

'*Shakhzade* must leave the town before his uncle takes him and the town captive,' Bab-Quli said in one breath. I was still in shock from the news of my father's death. I was not sure if I

should first mourn the death of my dear father or worry about my safety.

'Leaving Ferghana is not an option. I will not allow our enemies to succeed. Ferghana will have a new king,' my grandmother announced.

Before I understood what was happening, I was proclaimed the king of Ferghana. There was no celebration, no playing of the drums and no happy faces. The crowning ceremony was rushed and, at twelve years old, I became a king. Later that night, alone in my room, I watched the moon from my window. I missed my dear *ota* and cried. I promised myself I would follow my father's wish to protect the people of Ferghana and capture Samarkand.

Immediately after my father's death, we heard news of my uncle marching from Samarkand

towards Ferghana with his army. However, luck was not on his side. On his way, he came across many difficulties and finally he had to turn around. On his way back to Samarkand, he died of a high fever. A man who had set out to win Ferghana had lost his life instead. Immediately after his death, my second uncle took over Samarkand. Yet, after five months of ruling Samarkand, he too died from a severe illness. Following his death, his son Baysunghur Mirza became the king of Samarkand.

You might like to believe the life of a king is easy. It is indeed a matter of great pride to become

a king, but it comes with a lot of responsibilities. In the early days of my time as a king, I was lucky to have my grandmother by my side who constantly guided me and helped me. She was one of those exceptional women who were gifted at planning and coming up with ideas. My officers and I would often seek her help in political affairs.

Additionally, power can make a person insecure. My enemies tried to kill me on many occasions. It was common in those days to poison food. So, I became extremely wary of people around me and especially of what food I ate. I could trust no one.

Meanwhile, an opponent more powerful than any of my close relatives was on the rise. His name was Muhammad Shyabani Khan. Baysunghur Mirza tried to seek Shyabani's help in fighting against me. When the plan did not work out, Baysunghur Mirza fled the city, along with a couple of hundred of his followers. I knew this was the right moment for me to attack Samarkand. I surrounded the city for many months, stopping food from entering the city. Just as I had expected, the weary army and the inhabitants of Samarkand easily gave up the fight. In fact, when I entered the city along with my officers and soldiers, the people of Samarkand welcomed us warmly. No matter how many wars I would win later in my life, capturing Samarkand would always be my biggest achievement. At the age of

fifteen, I ruled two kingdoms, Ferghana and Samarkand.

As I entered the city of my dreams, I said a prayer in the loving memory of my dear father. He would have been so proud of me.

SAMARKAND, A TREASURE WON AND LOST

Samarkand was my goal, but little did I know it would not be my last destination. When you win a war, it does not necessarily mean you have no enemies. In fact, it could well mean you have gained new enemies. So victory over Samarkand was just the beginning of a series of battles in the days to come. I will tell you about it in detail as my story unfolds. For now, let me take you around Samarkand.

Words can barely describe the beauty of
Samarkand, the dream of every prince of my
land. It was the melting pot of all the peoples
and cultures that came here from different
parts of the world. Artists from Iran, Syria
and Hindustan made Samarkand the centre
of arts and architecture. Stonemasons came
from Hindustan and built handsome buildings
inspired by Samarkand's art. Vibrant turquoise
blue tiles decorated the mosques, palaces,
madrasas and houses.

Once I set foot in Samarkand, the first
thing I did was to go and visit the tombs of
those who had ruled Samarkand. The tombs
were in the garden near the fortress. I wished
I could build a tomb for my father there and
lay him alongside his ancestors. There were
many gardens in Samarkand with trees planted

on both sides and exquisite meadows. Apart from the marvellous gardens, there were many superb buildings around Samarkand. One of the most impressive was Koksaroy, a grand tower constructed by Timur. I took time to visit an ancient building called the Laqlaqa Mosque because I had been told about a strange event which took place in there. I was eager to see it for myself. I went to the mosque and, as instructed, I stamped on a certain place on the floor underneath the middle of the dome. I was amazed to hear the whole dome reverberate with a banging sound. No one knew the secret behind that strange sound.

The market was crowded with travellers and merchants. The best paper came from Samarkand and the red velvet of Samarkand was exported everywhere. As I walked around

the market, the air smelled of freshly baked bread and fresh fruits. *Ota* was right. The melons and pomegranates were delicious. So were the big juicy apples and ripe sweet grapes.

To the north of Samarkand lay a river and between the river and Samarkand was a hill named Kohak. On top of the hill was another superb building built by Ulugh Bek Mirza. It was an observatory. I was thrilled to go on the third and topmost floor of the building that had instruments through which I could look at the sky. At first, gazing at the sky with stars

spread above me was confusing. Then, as I watched the moon mystically move, growing and shrinking in size, I felt calm. As I became increasingly interested in gazing at the stars, I realised the best time to do so was on a dark winter night. After a long and busy day, I would go to the observatory at night and look up at the heavenly sky. I remembered my grandmother telling me our loved ones turn into stars after they die. There was one star shining brightest and I was sure it was my dear *ota* looking down on me.

Transoxiana, the province of Samarkand, was divided into many districts. The largest district, similar to the city of Samarkand, was Bukhara. Ah! How could I forget to mention the big juicy plums of Bukhara? They were the best. On the first night in Samarkand, we celebrated

our triumph by drinking Bukhara wines. No wine throughout Transoxiana was stronger and finer than Bukhara wines.

Victory can make a person feel powerful and admired. On the other hand, it can make you arrogant. In my case, arrogance got the better of me. As a result, my victory over Samarkand was short-lived. The long-drawn-out battle had caused the city to suffer greatly. The begs and soldiers who had supported me in the hope of being rewarded were badly disappointed. Soon, one by one, the soldiers left for their homes and eventually, their leaders followed. At the end, I was left in Samarkand with barely a thousand men.

To make things worse, I fell ill. The siege of Samarkand was the longest battle I had fought at that time in my life, and it had taken a toll

on my health. I could not speak or drink, let alone eat anything. I had difficulty swallowing my saliva. My body was feverish, and my lips were as dry as the desert. The doctor soaked a piece of cotton in water and dribbled the water into my mouth. In my dreams, I often saw my father sitting next to me and squeezing the sweet grapes of Samarkand onto my lips. Ah, the sweet grapes of Samarkand. And what a miserable way to enjoy them. Every morning, as I lay in my bed looking out of the window, the sun that rose in Ferghana would come to greet me in Samarkand. I missed my mother, my grandmother and my homeland terribly.

My warriors did not know what to do. Without a king they had no one to give them instructions. At the same time, all was not

well in Ferghana either. My enemies had been secretly conspiring against me to take over its capital, Andijan. Unfortunately, among many who were eyeing the city was my elder uncle Sultan Mahmud Khan. And why wouldn't he? Andijan was one of the most cultured cities of Ferghana. As a central trade route connecting east and west, it was an important city.

During my illness, my officers came to me with the news of a rebellion that had broken out in Ferghana. My loyal beg Ali Dost Taghai did his best to defend the Andijan fortress on my behalf. Before, Taghai had been one of the officers in Samarkand. Nonetheless, after my uncle's death, I appointed him as one of my officers. As a relative of my grandmother, I felt he was a nobleman who would remain loyal to me. At the same time, letters from my mother,

my grandmother and Khwaja Mawlana Qazi continued to arrive from Andijan.

They said the same thing: 'Please come back and save us. They have us under siege. Save Andijan from being taken.' I lay in bed feeling helpless.

Once my health improved, I marched out of Samarkand to win Ferghana back. It was too late. During my illness, a messenger who had come from Andijan had seen my condition. He went back and told Ali Dost Taghai about it. Having lost hope of my recovery, Taghai had handed over the fortress to the enemy. It was the same day I had left Samarkand. My heart bled when I came to know I had lost Ferghana. The agony didn't end there. On hearing that I was approaching Andijan, the enemy had killed Khwaja Mawlana Qazi at the fortress.

He was a saint and a brave man. I had fond memories of him.

'Love and kindness are the greatest virtues. Learn to forgive. A man without these qualities cannot be a king,' he would often advise me.

After his death, people close to him were arrested and killed. Luckily, the enemy was kind enough to send my mother and grandmother to the city of Khujand.

Before the news could sink in, we learned that Sultan Ali Mirza had seized Samarkand. I had forgotten I was a young Timurian prince and that there were many other Timurian princes who considered themselves rulers by birth. Samarkand, which was my father's dream, which was my dream, and which I had won with such difficulty, had slipped away from me in a hundred days.

Yesterday the powerful ruler of two realms, today I was a king without a kingdom. I had never known such pain or distress. Having lost two kingdoms and the trust of my family, my army and my people, I wept.

Most of the soldiers under my command left. Soon I had only around two to three hundred loyal men still with me. With everything lost, I left for Khujand where my mother and grandmother were.

Khujand was a miserable place to be. I am not sure if it was always that way or because being there reminded me of my defeat. The sole refuge I found in Khujand was at the tomb of Shaykh Maslaha.

Many days later, like a flicker of light at the end of a dark tunnel, a messenger came with a note from Ali Dost Taghai. Taghai had been

lucky to escape the enemy after the surrender of Andijan. He was guilty of the crime of surrendering Andijan to the enemy and he was keen to make up for it. He had sent the message in the hope that I would forgive him for his mistake. I did, and I joined forces with him. Together, we fought against my enemies, and I re-entered Ferghana.

Events in Samarkand had led to another change: now Shyabani ruled the city. I held many discussions with my begs and warriors on

how to take Samarkand back. They suggested that since Shyabani was away in Bukhara, and the people of Samarkand were not yet loyal to him, it would be the right time to attack the city. Therefore, I immediately left for Samarkand.

With slightly over two hundred men, I entered the city at night. We climbed up the walls of the fortress before the sun rose. When we arrived inside Samarkand, the people were filled with joy and welcomed us with food and drink. When Shyabani heard the news, he arrived at the gates of Samarkand with his men. Yet, when he saw the support of the people for us, he accepted he could do nothing, and he returned to Bukhara.

I immediately sent for my mother and grandmother, and they joined me in Samarkand.

During this excitement and danger, I got married. I married Ayisha Sultan Begum. We were engaged at an early age. In those times, it was not common to marry for love. Marriages were arranged by parents and the reasons to get married were different. A king could have as many wives as he pleased, and having many wives meant being wealthy. Kings liked to give away their daughters to other powerful kings as a gesture of friendship. That ensured they wouldn't be attacked by their rival and would be helped if another king attacked them. Most princes and princesses were aware of that fact and so were Ayisha and I. Our fathers were kings of two powerful cities. So, when our two families were bound together by marriage, we were certainly more powerful.

However, relationships, especially between a husband and wife, do not always work that way. Ayisha and I were too young to understand the seriousness of our relationship. We used to fight a lot. Soon, I lost interest in her. Ultimately, we got divorced. Ayisha was my first wife. Like my father and my uncles, I too had many wives and I had altogether four sons and four daughters. I then realised it was not a struggle to remember the names of your own wives and children.

Outwardly, I had to maintain the image of a king, yet deep inside I was a young boy of fifteen. I longed for company. I had been so busy with battles that I neglected the affairs of the heart. I had forgotten to love and care for another human being. In such times, a boy named Baburi fascinated me. One of the reasons for this might be because his name

was similar to my own name. I saw him first at the camp market. I did not have any friends and seeing Baburi made me want to be friends with him. The heart often plays strange games. I liked him so much I wrote poems for him. I wanted to meet him but when I did meet him, I would be tongue-tied.

However, there was no time for personal relationships. I had long learnt my lesson that as a king I had to first make my army strong. As a result, unlike after my siege of Samarkand, I did not waste my time celebrating the victory. Within the next few months, I had gathered my forces to prepare to fight Shyabani.

Then I made a terrible mistake. I went into battle too quickly and it cost me the war. I saw my men being killed mercilessly. My soldiers and I plunged into the Kohak River with our

horses while arrows zoomed past our ears. We swam across the river and reached Samarkand. Many of my brave men were killed and others were injured. The survivors were scattered and once again I was left in Samarkand without enough men to hold onto it.

Shyabani would not abandon the fight easily. Somehow, for several months, I defended the city from him.

'My lord, the situation is getting worse. Our people are suffering because of the short supply of food. Even the horses are fed leaves. If this situation continues, it will eventually lead to desperation among people. Some of them have already left the fort. We must take a decision as soon as possible,' one of the begs reported.

'What about the help we sent for?' I asked.

The beg
stood with his head
hung low. I understood that
Samarkand was slowly slipping through
my fingers again. If I wanted to fight Shyabani
and get Samarkand back, I had to stay alive.
As planned, one night, along with my mother
and a few others, I secretly left Samarkand. It
was one of those long cold nights that I would
have happily spent at the observatory gazing
at the stars in the clear sky. As we rode on our
horses along the narrow streets of the city, my
heart pounded so loud I thought it might wake
everyone. The palaces, mosques, meadows and
gardens of Samarkand stood silent, bidding us
farewell. As we crept out of the Iron Gate, I
turned back.

The heavy doors of the gate closed behind us, and I caught a glimpse of the dome of the Bibi Khanum mosque. Once outside the gate, there was no time for us to stop and admire the beautiful countryside which we passed through. We lost our way among canals, raced past villages, I fell off my horse and at times, we trudged up hills.

Finally, we reached the village of Djizzak. The headman of the village welcomed us with meat, bread and fruits. We were about to start a new life.

HARDSHIP AND RESCUE

Nothing and no one can make a person in exile happy. It breaks your heart and crushes your spirits. The first years in Djizzak, after I left Samarkand, were full of appreciation of a new-found life, though soon I had to face worse hardship and misery than I had ever experienced in my life. I had no army, no money and no kingdom. I was a poor man, a powerless wanderer. Bareheaded and barefoot, I travelled

around aimlessly, taking refuge in the villages, hills and mountains of Central Asia. I was inexperienced and made one mistake after the other. I took hasty decisions, made the wrong plans, and often underestimated my enemy. Many a time, I was vulnerable. Finally, I reached a point when I gave up on life and prepared myself for death.

After staying in Djizzak for a short period of time, we left for Tashkent to meet my mother's family. She had not seen them for over thirteen years. After a few months in Tashkent, my mother fell ill and she worried about me a lot. Meanwhile, begs and princes from surrounding cities continued to attack each other. Occasionally, we heard news of Shyabani raiding cities as well.

My time in exile gave me a chance to experience the lives of ordinary people and to enjoy the simple pleasures of country life. My love and respect for the country people grew. Often, I delighted in spending time in a mountain village with the headman's mother who was 111 years old! She used to tell me stories of Timur's invasion of Hindustan. Among many things, I heard about a beast in Hindustan called an elephant and a colourful bird called a peacock. Both fascinated me. I was similarly in awe of the story about a precious stone called the Koh-i-noor. It made my heart long to go to Hindustan.

I enjoyed going for long walks in the surrounding mountains. The mountains offered me peace and calm. I would sit there for hours and write poems. It was a strange

time. Hands that once held the sword now held a pen. I knew moments of uncertainty and despair. I would often think that my life was useless, as I wandered aimlessly from mountain to mountain with no kingdom and no place to stay.

One day, we received news that my uncle Kichik Khan was on his way to Tashkent. I overheard other men talk about my uncle's reputation for justice and how respectable a man he was. When I finally met him, he impressed me. He was quite rough in his ways and his speech was direct. He arrived with over a thousand men on horseback. They wore Mongolian hats and embroidered Chinese tunics. As everyone sat down for a meal, I was in awe of his personality and did not dare go near him.

The next morning, he called me to his tent. And, to my utmost surprise and following the Mughal custom, he presented me with a robe, boots, a quiver, a Mughal hat, an embroidered Chinese tunic and a saddle.

'Dear uncle, I do not have a horse,' I told him when he offered me the saddle.

'Of course you do!' he said with a big smile on his face and took me out of the tent, with his arm around my shoulder.

Outside the tent, tied to a tree, stood his horse.

'A warrior is incomplete without a horse. I would like to give Sikandar, my horse, to you.'

His gesture overwhelmed me. I kissed his hands and thanked him for his generosity.

Sikandar was a stunning, chestnut Arabian stallion. Ah! How big and gentle his eyes were. I immediately fell in love with him. I

went close to him and held his rein with one hand and softly patted his neck with the other. 'Sikandar...' I softly murmured.

He nudged and rested his head on me.

'He likes you already,' my uncle said, and he laughed out loud.

I grabbed Sikandar's mane and mounted him. He lifted his hind legs up in the air and neighed. After trotting for a while, I tugged on his reins and off we galloped to the top of the mountain. Wearing the robe, carrying a quiver full of arrows and riding the horse filled me with happiness and pride. I felt powerful again. I was ready to take on the world.

'*Uukhai*!' I let out the battle cry.

I no longer relied on myself alone: in Sikandar, I had finally found a faithful friend to whom I could confide my heart's inner secrets.

My uncle and I led our soldiers to Andijan against Sultan Ahmad Tambal. I had not forgotten how Tambal had betrayed me by rebelling against me and by setting up my brother Jahangir on the throne of Ferghana. But Tambal's army proved stronger, and we had no other option but to pull back and retreat.

Tambal's younger brother Shaykh-Bayazid ruled over Akshi. We made a promise that I would leave my uncles while he would leave Tambal. To show his friendship, Shaykh-Bayazid invited me and my younger brother Jahangir to Akhsi. When we reached Akshi, Shaykh-Bayazid came out to greet me and Jahangir. However, despite Shaykh-Bayazid's warm welcome, Jahangir did not seem to trust him. To my surprise, Jahangir ordered his men to capture Shayakh-Bayazid. That put an end

to our thoughts for peace and agreement. Suddenly, we were fighting each other again. In the chaos, Shaykh-Bayazid could make a good escape. My men were outnumbered and spread out in all directions. Inexperience had plunged me into difficulty again. Still, I managed to flee from Akhsi and I ran for my life.

Soon, two of Shaykh-Bayazid's horsemen closed in on me. They promised me they had come to take me back to make me their emperor. Though I had my doubts, I wanted to get out of the danger I found myself in and reach a safe place. So I told them to guide me by riding ahead of me. I kept behind to keep an eye on them. After travelling a long distance, one of the men suggested we stop to rest. He took us to a garden with empty orchards nearby and a stream running through it. Simultaneously, a

soldier appeared and captured me on the orders of Shaykh-Bayazid's men.

I had been trapped. I stood there filled with fear. I gave up any hope of escape.

What difference would it make if I lived a hundred or a thousand years when the end resulted in death? I thought.

I fell on my knees to ask God for His mercy before I died. I closed my eyes to say my last prayers. As I prayed, Saint Khwaja Ya'qub, my spiritual leader, appeared before me. A group of men surrounded him, and he said they were there to help me regain my royal status. He added that I should speak to the saints whenever I was in trouble.

I opened my eyes and to my huge surprise, two horsemen crashed through the orchard wall. They had been faithful servants to me

for many years. They captured the enemy and then knelt respectfully at my feet. Surprised at their unexpected arrival, I asked them how they had found out where I was. One of them told of a dream he had in which a saint had given him clear instructions how to find me. They had then set out on their journey to fetch me. Hearing his story, I was in total disbelief. I thanked God for His mercy.

Once back in Andijan, I met my uncles and told them about my experiences of the recent days. In the next few months, hundreds of my followers returned to me from wherever they had fled to. Their return filled me with hope of a better future.

Often, I would recall that dreadful moment when I was resigned completely to my fate and had knelt at the mercy of my enemies. I

was known as Babur, the brave. I had fought and won Samarkand, a city many princes had failed to capture. I had trained in the martial arts and had survived many battles. Why, then, was I so helpless before them? What had happened to me?

I then understood a person's strength to overcome difficulties lies in his willpower, determination and courage rather than in his muscles or his fighting skills. Years of setbacks and hardship during my exile had made me lose these qualities. Hence, it is important that no matter what difficulties you go through in life, you must maintain a strong will and you should not hesitate.

Experience had made me wiser and stronger.

THE EXPEDITION TO KABUL

I might have lost everything except for hope. Being a direct descendant of the great warriors Genghis Khan and Timur, fighting was in my blood. And so I spent the next seven years of my life recruiting and strengthening my army. It was the time when I considered myself a grown man. One reason for this was because when I had turned twenty-three years of age, I used my first

razor. But the main reason why I felt I had grown up was because I felt I had changed mentally. I experienced the loss of my loved ones and I faced a natural disaster that previously I had only heard of. I conquered Kabul and became so lost in the charm of its luscious countryside, excellent climate and delicious fruits that I made it my home for the next twenty years. I had no clue then that what followed next would change the course of my life. Kabul was where I would launch my invasion of Hindustan and eventually establish the Mughal Empire.

After my return to Andijan, many men, sultans and the *mirzas* from other regions joined me with great expectations. I had experienced many times in the past that being powerful did attract people, but I had learnt that it didn't necessarily

mean they were your well-wishers and friends. I knew one of the main reasons for them to join me was Shyabani – our common enemy.

I took my small army and moved towards Hissar. Khushrawshah ruled Hissar. He was a former minister of Samarkand who had become an independent ruler. On hearing about our approaching army, Khushrawshah's younger brother Baqi Beg Chaghaniani sent messages to me with offers to join me. When Khushrawshah saw his men were leaving him one after the other, he lost hope and sought a treaty. It would be a better choice to let him go and to take his army into mine. I granted him his wish. Khushrawshah's forces now made up a large part of my army.

Shyabani continued to take down one Timurian prince after another. I knew I

had to defeat him at all costs if I wanted to regain my power. To achieve that, I would first have to move to the remotest and safest place possible to set up my camp. Then I could build up my army and make plans to fight Shyabani, or anybody else. Baqi Beg Chaghaniani advised I go to Kabul and make it my kingdom.

At this point, I should tell you something of Kabul. When my grandfather had divided the Timurian Empire and shared out the cities to his sons, my uncle Ulugh Bek took over Kabul and Ghazni. When my uncle died, his son was an infant. Taking advantage of the situation, one of his ministers took over the city by force. Later, my uncle's son-in-law Muhammad Mukim Beg Arghun drove out the minister and became the new ruler.

On our way to Kabul, we had to cross the Hindu Kush mountain range with numerous high snow-capped peaks and narrow passes. Kabul was well-fortified and located high up in a narrow valley, making it difficult for foreign enemies to invade. To the north of the city wall stood Kabul's fortress, overlooking a large lake and three meadows. It was such a magnificent sight. Vast and spectacular, Kabul was a major trading centre. Caravans from Ferghana, Samarkand, Bukhara and other regions came to Kabul. Similarly, every year, thousands of horses, along with cloth, sugar, spices and precious stones came to Kabul from Hindustan.

We travelled day and night with short breaks in between to eat and rest. One such time, after travelling throughout the day and evening, it was quite dark by the time we stopped to rest.

It was a starry night. I lay down on my back looking at the sky while my horse Sikandar took a short snooze close by. Far off near the southern horizon, I noticed a dazzling star.

'Sikandar, look over there! It's the star of Canopus,' I whispered aloud.

As though he had understood me, Sikandar opened his eyes and had his ears forward and alert.

'Do you know that Canopus is a sign of fortune?' I said.

Sikandar sighed and went back to sleep again. I watched the star in the sky and wished I could be in Samarkand. It would have been a perfect night to watch the second-brightest star in the heavens from the observatory.

We continued our travels and finally crossed the mountains. Once we reached Kabul, Mukim Beg surrendered and I allowed him

to leave for Kandahar to be with his father and brother. Without any bloodshed, I had conquered Kabul and Ghazni. I was back to being an independent ruler.

Kabul was a city full of strange stories. My favourite among them was about the so-called 'Island of Happiness'. According to a legend, there was a lake in Kabul in the middle of which was the Island of Happiness. This legend said that a joyous family of musicians lived on the island, and the sweet sound of their harp could hypnotise anyone.

After Samarkand, Kabul impressed me the most deeply. It stretched from east to west and was surrounded by mountains that stayed snow-covered all year round. The mountain slopes were rich with vineyards while tulips of many varieties covered the foothills.

Every morning, I loved eating fresh peaches and apples with bread dipped in honey. This came from the beehives that were kept in the mountains around Kabul. In the afternoon, I would snack on almonds and nuts.

The city itself had many gardens, springs, palaces and bazaars. Unlike the extreme conditions of Samarkand, the weather in Kabul was mild and pleasant throughout the seasons.

As I went for a walk in the bazaars, it was fascinating to see many different tribes. It was not a surprise that there were over ten languages spoken in Kabul. The houses were two or three storeys high and built of burnt bricks.

After I had conquered Kabul and Ghazni, I rewarded my brothers. I gave Ghazni to Jahangir

and another province, Ningnahar, to Nasir. Just like Khujand, Ghazni was another truly miserable place to be in. The only things I liked about Ghazni were its grapes and melons. They were even better than those of Kabul. These fruits, including apples, were exported to Hindustan.

Though not as bad as in Samarkand, the wealth in Kabul was limited and many of my followers expected rewards. The only way out appeared to be to put heavy taxes on my people which I knew would make me unpopular. I needed to find another solution to the problem soon. So, I called in my men to decide on which nearby area to explore for the next stage in our campaign. From a few names suggested, I decided on Hindustan.

On the first month of the new year, we rode out to Hindustan. We planned to cross

the mighty River Indus. But then Baqi Beg Chaghaniani, one of my chief advisors, recommended we should raid a nearby place called Kohat instead. According to him, by doing so, we would not have to cross the river and there would be many tribes with large herds of animals and riches for us to lay our hands on at Kohat. So we cancelled our plan to cross the Indus and go towards Hindustan. We marched towards Kohat instead.

We raided Kohat and moved camp from one place to another, making constant raids on our way. We made a great many Afghans our prisoners. After our return to Kabul, we planned to raid Kandahar next, and we began our preparations to do so.

Still another, deeper, source of woe awaited me. My mother's health had been getting worse

ever since we had gone to visit her family in Tashkent. She had never recovered fully after that. In Kabul, she suffered from severe fever and finally passed away.

The least I could do for her was to construct a tomb in the garden on the mountain slope. As I sat beside her tomb, I remembered how loving my mother had been. She had a led a happy life while *ota* was alive. His unexpected death had left her devastated and it affected her health severely. I was so busy trying to regain my power that I hardly had any time to spend with my mother. When I captured Kabul, I had thought I would finally live a stable life and make my mother happy again. Unfortunately, she did not live to enjoy this. I remembered the good times we had spent together. The times she had been by my side, loved me, cared for

me and motivated me. Unfortunately, I had never said thank you to her for her sacrifices. I regretted not having spent more time with her and not to have told her how much I loved her. But it was a lesson learnt too late now.

While I mourned her death, I received news of the death of my younger uncle. I was beside myself with grief. And before I could come to terms with this second bereavement, news of a third death completely shattered me. I was informed that my dear grandmother Esan Dawlat Begim had passed away. Her dream was to see me become victorious and carry on the family legacy. I started to feel extremely lonely.

Carrying out the rituals of mourning, I handed out food to the poor and prayed for the souls of my mother, my uncle and my grandmother. I then immediately turned my

attention towards my kingdom. I took off the black mourning clothes and put on my robe, pulled on my boots, shouldered my quiver of arrows and mounted Sikandar. Just as in our original plan, I was now ready to go on our journey to Kandahar.

We had not travelled far when I fell ill. I remember feeling tired and sleepy. When I woke up, a week had already passed by. Baqi Chaghaniani told me later that no matter how many times he tried to wake me up, I would open my eyes and then immediately fall back asleep again. It amused me greatly.

Since I was too weak to travel, we decided to stop for a few days. After all that I had gone through in the recent past, I thought it was the right decision to rest for a while. I wrote poems and listened to music to keep myself

happy. That helped distract me from being miserable and thinking about my mother and my grandmother.

Nurullah was one of the best musicians in Kabul and he would play for me every afternoon. One day, he played the *saz* for me with another musician sitting beside him. As he plucked on the strings of the long-necked instrument, I closed my eyes and listened to the music that reverberated from the tear-shaped *saz*. Tears began to roll down my cheeks. I realised I had not shed a single tear since my mother had died. The pain of separation was appalling.

Once the music finished and the musicians picked up their instruments to leave, I heard Sikandar neigh outside the tent, followed by other horses. I felt the earth move as Nurullah

and the other musician bumped into each other. They dropped the instruments that they were carrying.

Everything happened so quickly that before I could make sense of what was going on, I heard people running around shouting,

'It's an earthquake! It's an earthquake!'

For a moment, I froze with my heart pounding heavily. I knew I had to get out of the tent before it came falling on me and so I staggered out. As I came out of the tent, I saw dust rising from the summits of the mountains in front of me.

'Is this the end?' I panicked.

Just then, I heard Sikandar neigh again. I turned to look towards Sikandar and saw him break his rope loose and gallop away as I called out his name.

Earthquakes were nothing new in Kabul, but for me, it was my first experience. I was scared and it made me feel weak and helpless. The incident made me realise the power of nature over humans. Until then, I had been lucky to experience the gentle and beautiful side of nature. Now I had seen the other side of it and it wasn't a pleasant side.

Forts and walls had collapsed, and houses had turned into rubble. Many people had died under the debris. I shuddered to see the earth split wide open and the hole looked deep.

By evening, Sikandar had returned. I ran to him and put my arms around him. I had always

been surrounded by people who I could rarely trust. Even close family members such as uncles and brothers were ready to go against each other for personal gain. Sikandar proved that staying loyal can be a struggle for humans but not for horses.

Right after the earthquake, I had immediately ordered my begs and soldiers to attend to the needy and to repair the damage. People worked together voluntarily and helped each other to rebuild their houses. In less than a month, the cracks in the fortress were fixed, houses rebuilt and life was getting back to normal again. All the same, the incident had

left cracks in our hearts that would take a long time to heal.

With the passing of time, Baqi Beg Chaghaniani had turned into a spiteful and evil person. He used his position to bully others and he was not on good terms with anyone. During our journey at every campsite, he would not share any of his personal food even though our warriors stayed hungry. He was extremely jealous of other begs and would punish anyone who went against his ideas. Promoting him did not do him any good. As a result, I had to dismiss him from my army. He took his family and left for Hindustan. On his way, one of his enemies killed him.

The year had been full of loss. During those hard times, I did not allow the fire within me to die down. I was not the type of person who

would give up that easily. Things can go wrong, but doing nothing about it makes matters worse.

Soon, I was ready to strike again.

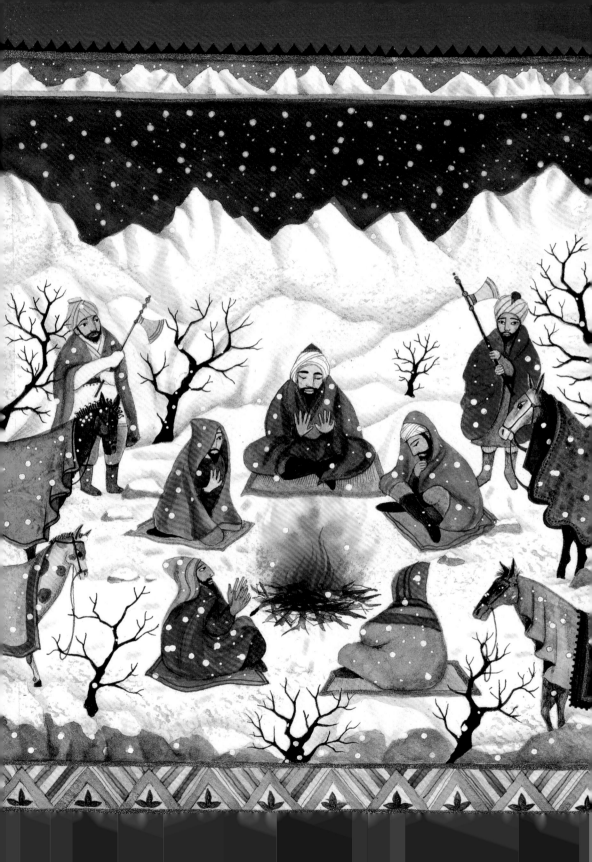

5

FAMILY AFFAIRS

One of the most unforgettable experiences of my youth was my trip to Herat. Early on in life, I had become a king, had fought many battles, suffered losses and taken upon myself many responsibilities. Due to all this, I had forgotten to enjoy life. My trip to Herat reminded me that I had to learn to enjoy life to the full. While in Herat, I met a young and attractive woman whom I later married. On

my way back to Kabul, I came face to face with nature at its most hostile. The journey made me aware that life was unpredictable. Our lives could easily change in the blink of an eye. The journey to our dream lands takes time, dedication, patience and a lot of hard work. At times, it becomes tiring and there is no shame in resting for a while, but then we must continue with the journey again. Our experiences make up what is called life and the best way to experience life is by travelling.

Sultan Husayn Mirza invited me to Herat. I had never met him and knew of him only as one of my distant Timurid relatives. He had been trying to unite the Timurid princes to fight against Shyabani. At a time when the Timurian princes fought one another, Sultan Husayn Mirza's proposal was a very positive gesture.

Sultan Husayn Mirza was known as a brave ruler with a great sense of humour. Of all Timur's descendants, no one was known to have used the sword as skilfully as he did. I looked forward to meeting him in person and learning tips and tricks about sword fighting.

Sadly, on our way to Herat we received news of his death. I was extremely disappointed to have missed the opportunity of meeting a man of his status. Nonetheless, I decided I should continue with our journey and meet his sons. I was sure that they were more than eager to fulfil their father's dream of uniting the princes.

When I arrived in Herat, Sultan Husayn Mirza's eldest son, Badiuzzaman, welcomed me. I expressed my condolences to him for the death of his father.

A few days after my arrival, Badiuzzaman organised a party. Large magnificently decorated tents were set up on the bank of a river. I was welcomed inside one of the tents and people stepped aside to make way for me and bowed their heads as a mark of respect.

'Welcome, my dear brother,' Badiuzzaman greeted me with open arms and hugged me tightly.

Everyone cheered the occasion. I had never been so warmly welcomed by any of my cousins before. Happiness overwhelmed me. The tables were piled with meat, fruits and drinks. The party lasted until the early hours of the morning.

Many of my aunts, their daughters and other women had gathered in Herat to pay homage at Sultan Husayn Mirza's tomb. That is when I first laid my eyes on Ayisha Sultan Begum and fell in love with her. Later, I came to learn

that she had fallen in love with me at the same time. I asked for help from my aunts to take the matter further. They decided that she would come to Kabul after I had returned there.

Since plans for battle had been paused, I had plenty of time at my disposal. It was a strange feeling to live each day not having to make plans about whom to raid or how to protect ourselves. Every day I went sightseeing and visited tombs, meadows, gardens, riverbanks, mosques, *madrasas*, forts, baths and hospitals. It didn't take me long to understand why Herat was called the cultural capital of the region. Seeing the city filled with people of extraordinary talents amazed me. The place was full of the best poets, musicians, artists and scholars.

I soon understood that, unlike their father Sultan Husayn Mirza, my cousins had little interest in war. Many a time I tried to bring up the topic of their father's dream of fighting against Shyabani. They immediately dismissed it. I did not blame them for this because Herat was a place where anyone might wish to become an artist. And when a person devotes themselves to art, fighting is the last thing they want to do.

A few days later, Badiuzzaman Mirza's younger brother Muzaffar Mirza sent me an invitation to a party. The party was held in a charming small garden. In the middle of the garden was a two-storey building. Some musicians played the harp while others played the flute, joined by a singer who sang superbly. The walls of the main room inside the building were painted with scenes of battle. I was

speechless with joy looking at the paintings of the battles and campaigns of our grandfather Sultan Abusai'd Mirza.

There were also paintings of his father Sultan Husayn Mirza. I could easily recognise him from his white beard, karacul cap and brightly coloured silk robes. Over dinner, Muzaffar Mirza told me his father got his caps from Bukhara as that was where this type of hat originally came from. They were made from the black wool of a certain breed of sheep. What fascinated me most was that Husayn Mirza wrote poems too, under the pen name of Husayni. Thanks to him, different forms of art and literature, especially poetry, flourished during his period in Herat.

Among the many parties I attended in Herat, one would remain special to me. An

amusing incident took place there. We sat in an open pavilion surrounded by willow trees. In one corner, the musicians played their instruments and people danced to the music. Badiuzzaman sat next to me while other guests sat around the tables that were loaded down with delicious food and drinks. Servants stood next to us, waving long scarves to ward off flies. As we sat there enjoying ourselves, we were served a roasted goose. The others started to carve their goose and eat, but I looked at the dish in front of me feeling totally embarrassed. By the age of twenty-four, I had certainly accomplished a lot as a warrior, however I had never learnt the essential skill of how to carve a goose.

'Do you not care for it?' Badiuzzaman asked, noticing my nervousness.

I told him I did not know how to carve a goose. The next moment, Badiuzzaman pulled the tray towards him and with a long, sharp carving knife cut through the skin between the leg and the breast of the goose. He then cut through the hip joint, removing the entire leg from the main body. With long, even strokes he sliced the goose into bite-sized pieces held together by the fatty top strap and gave the tray back to me.

I felt like a happy little boy seated next to my cousin. I felt safe in his company. At the end of the party, he handed me a jewel-studded belt and a dagger as a gift. It reminded me of my uncle Kichik Khan. I realised that, while growing up, many kinds of relationships matter. For a young man of my age, it was important to have older brothers and cousins to look up to and learn from.

Winter set in and Shyabani abandoned his plan of attacking Herat. By then, I had come to understand the Mirzas' lack of interest in warfare. I had also forgotten my duties as a king who had set out on a journey with a purpose.

It was time to turn my thoughts to Kabul. Despite repeated requests from the Mirza brothers for me to spend the winter in Herat, I decided to return to Kabul. Never had I felt as miserable as I did when I said farewell to the Mirzas. The warm-hearted company of my cousins in the cheerful freedom of Herat would remain a fond memory for the rest of my life. The journey had proved fruitless when it came to fighting Shyabani. But I had the chance to experience again the love and closeness of family. The experience was priceless.

The shortest route from Herat to Kabul was through the snow-capped mountains. Though short, mountain roads during winter are filled with danger. Compared to this route, the Kandahar route was safer, even if longer. By this point, I was impatient to be in Kabul and wanted to reach there as soon as possible. That is why I made the serious mistake of taking the shorter route.

Unaware of what lay ahead of us, we began our journey back to Kabul. As we marched further ahead, the snow started to get deeper and deeper. We reached a point when there was no trace of the road, and we lost our way. I sent my men to find a road and someone who could guide us out of this snow-covered region. Meanwhile we turned back a short way and camped at a spot where we could make a

fire. The men who had gone to look for a guide returned empty-handed. We had come too far to return to Herat and waiting at the camp for help could cost us our lives. I decided we should trace back our route to the point where we lost sight of the road.

For a week we moved around, first on our horses and later on foot. The snow was sometimes chest-high, and we frequently found ourselves sinking into it. The icy wind lashed my cheeks. My warriors hung their heads low, while the horses stopped moving every few paces. I often stopped to look around and saw nothing aside from a vast stretch of snow and ice. My bones ached and I became tired. We were exhausted.

'Is there any sense in trudging through the snow when we have no clue where we are going?' I asked myself.

On top of that, a heavy snowstorm hit us. Days during winter were short and soon it would be dark. I knew if we did not find a shelter we would soon die. I heard someone shout that there were caves nearby. Hope filled me. As the storm grew worse, we struggled to reach the caves in the mountains.

To my disappointment, the caves looked small. I could not leave my warriors out in the open to die while I slept inside. They had been by my side through all my hardships, and I made sure I suffered everything they did. We dug our way deep into the cave and soon grasped that it was big enough for everyone to fit inside. Once in the cave, we huddled

together for warmth and shared whatever food we had. It became extremely cold during the night, and I doubted if we would make it to the next morning. Nature had once again shown its unforgiving side and showed me how weak and helpless we humans are.

'Was there any cruelty or misery I had not suffered in my life? Was there any pain that had not wounded my heart?' I wondered.

I know for sure it was our prayers that kept us alive during this ordeal.

The storm stopped the next morning, and we set out at dawn and reached the top of the pass. We then walked past the valley with treacherous slopes around it and finally crossed the other side of the pass. No one had ever crossed that pass before, and we did not know how we managed it, especially at that cruel time

of the year. Without the snow we would have been stuck on the slopes and our horses would have never made it down.

By the time we reached the nearest village, people there came to know of our arrival. They greeted us and the horses with warm food and water. Those who have been through similar hardships could understand how grateful we were for food after what we had been through. After resting in the village, we continued our journey towards Kabul.

Meanwhile, I discovered that my enemies had spread the rumour that Badiuzzaman Mirza and Muzffar Mirza were holding me prisoner. After tricking the people with these lies, they plotted their siege of Kabul. The rebels were my cousins Mirza Khan and Muhammad-Husayn Mirza. We attacked and arrested them but,

because I had learnt to value relationships more than before, I did not punish them. They were set free to go to Herat.

Once things were settled, I went to the hills in Kabul to take a break. I wanted to spend time alone by myself. The spring season meant the hills were extremely beautiful with tulips and lush green trees everywhere. I had always appreciated the beauty of Kabul. Now I had learnt to value life and I felt blessed to be alive. The beauty of Kabul astounded me, and I exclaimed the lines of a famous poet:

Agar firdaus bar roo-e zameen ast,
Hameen ast-o hameen ast-o hameen ast.
(If there is a paradise on earth,
It is this, it is this, it is this.)

6

RISE OF THE EMPEROR

Every human being born on this earth lives a life of his or her own. Yet few people experience in their early years what comes to others over the course of a lifetime. I was one of those who experienced things early in life. Everything in my past seemed to have been a preparation for what happened in the days to come. My past experiences on the battlefields had taught me

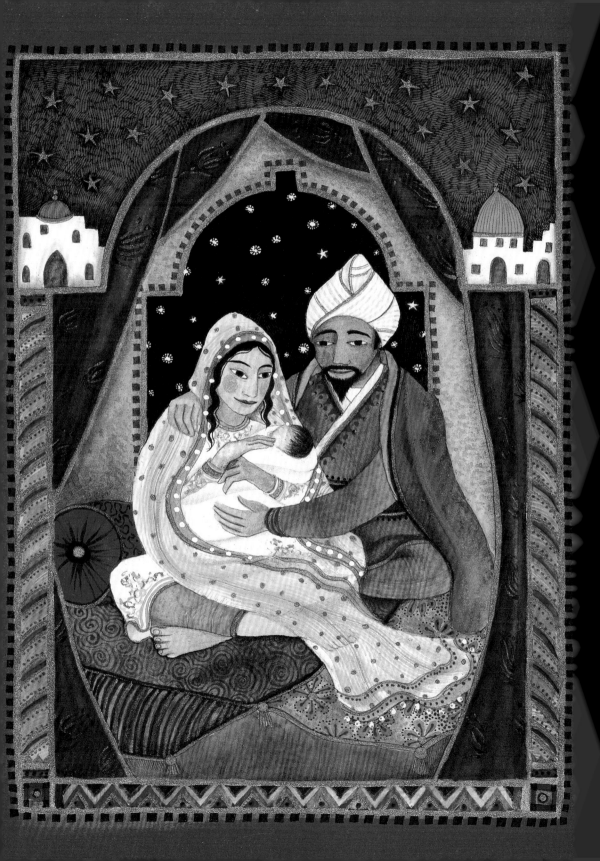

how to turn my men into a fighting power. I had also learnt that luck is not always on one's side. I had become the new padishah, or emperor, of the Timurid dynasty. But strangely, I experienced a feeling of emptiness within me while at the height of my success.

Nothing had prepared me for fatherhood. The birth of my eldest son Humayun was the greatest moment of my life. At one moment I saw my father in him, and then I saw another version of myself in him. What a miracle the birth of a child is!

Until that time Herat had been ruled by members of the Timurid dynasty. My wonderful experience at Herat had made me proud that the Timurid princes still ruled some cities. I dreamt there was a possibility of us uniting to

fight against our common enemy, Shyabani. Unfortunately, that year, after my return to Kabul, Shyabani had attacked Herat and captured it. Once he was inside the fortress, he ill-treated my cousins and their family members. Several of my family escaped from Herat and came to Kabul. I welcomed them with open arms.

Eventually, the Timurid princes offered the title of *padishah* to me. It was a source of great pride. My great-great-great-grandfather Timur had been the emperor of the Timurid dynasty and with Herat lost to Shyabani, I was now the only remaining ruling Timurid prince. On a personal level, it was a time to celebrate. So why was my heart filled with a sense of grief and loneliness?

I later understood that I felt this way because, in my mad quest to be a Timurid

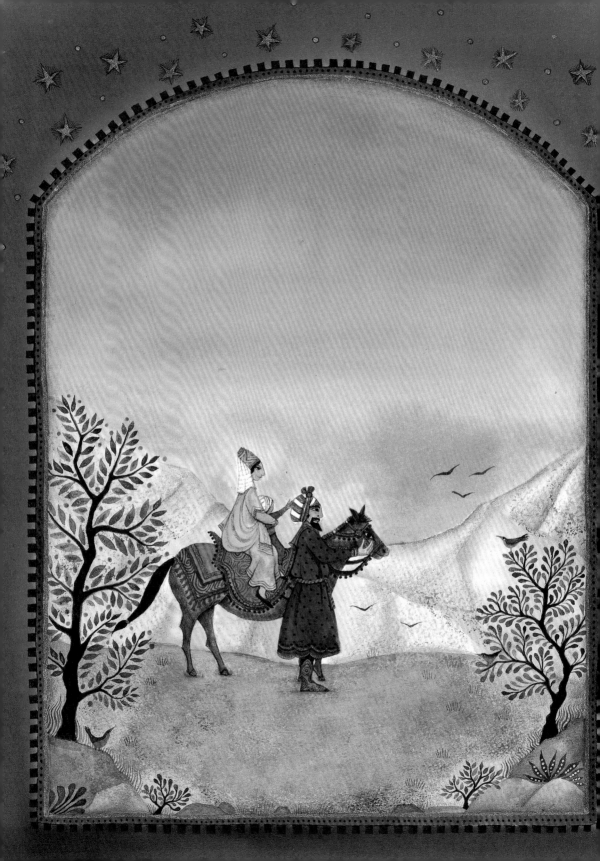

emperor, I had fought against my own brothers and uncles. We were enemies within our own family. We had lost most of our ancestors' lands. Many Timurid princes had fled to Kabul not because we had united as brothers, but out of fear of Shyabani. The thought filled my heart with a sense of great regret and sorrow. The title of *padishah* felt unimportant to me.

I asked myself, 'Were my efforts and achievements for nothing?'

No, everything I had gone through could not have been for nothing. I promised myself to try my best not to let the Timurid dynasty become divided again.

My late uncle Husayn Bayqarah had appointed Dhul-nun Beg Arghun as governor of Kandahar. After Dhul-nun Beg's death, his sons Shah Beg Arghun and Makim Beg Arghun

inherited Kandahar. Since Shyabani had already captured Herat, the brothers feared that Shyabani would attack Kandahar next. So they wrote letters to me, seeking my help.

There is a popular saying, 'The enemy of my enemy is my friend'. The Arghuns and Shyabani were enemies, and Shyabani was my enemy too. Since there was no chance of me being a friend of Shyabani, I thought it would be a wise step for me to make friends with the Arghuns and fight against Shyabani. Forgetting my hostility to the Arghuns, I made my journey towards Kandahar. However, this new friendship would not last long. As I neared Kandahar, I received news that the brothers had changed their minds and no longer wanted my help.

Though I could not know the real reason for the Arghuns' change of heart, one thing

I knew for sure was that they were now my enemies. For as long as Shah Beg and Makim Beg remained in Kandahar they would be a threat to me. It was best for me to continue my advance towards Kandahar and fight the Arghun brothers.

Hearing the news of my advance, the brothers positioned themselves in the woods outside the city. When I reached the edge of the city, a small battle took place with no win for either side. The Arghuns' forces consisted of thousands of men that were split into two parts, each led by one of the two brothers. On the other hand, most of my men had either died or been forced to flee, leaving me with a limited number of soldiers. We were badly outnumbered.

As a commander I knew an army's success depended on strategy, morale and cunning

rather than numbers alone. I put my faith in God and ordered my men to attack. The arrows flew from both sides. Luckily, several of the Arghuns' men betrayed their masters and joined my side. This turned the tide of the battle and soon the brothers had no choice but to flee the battlefield. Some of the Arghun brothers' men who were inside the fortress showed their loyalty towards me and opened the fortress gate for my men. Shah Beg and Makim Beg were arrested, but their men begged me to spare their lives. I granted their wish in return for the loyalty these men had shown towards me by letting me inside the fortress.

Though I had gained control of the city, I had no plans to live there. I would not leave Kabul for any other city in the world. Therefore, I made my younger brother Nasir

the king of Kandahar and prepared to leave for Kabul.

On our way, we camped in a meadow for a few days to distribute the loot. The chests and sacks full of treasure took me by surprise. I had no idea that Shah Beg and Makim Beg had so much in their possession. It was difficult to count and make a list of the silver coins, which had to be weighed on scales and divided among everyone. We returned to Kabul rich and happy.

Those days, the stars were in my favour because the arrival of Ayisha Sultan Begum to Kabul followed my victory in Kandahar. She kept the promise she had made to me in Herat. We married immediately.

Not a week had passed when I heard the news that Shyabani had laid siege to Kandahar. During that time, my brother Nasir was away

at Ghazni. The unexpected arrival of Shyabani had surprised the guards of the city. Kandahar would soon surrender before the mighty army of Shyabani.

I must admit that the news made me panic. Surely after Kandahar, Shyabani's next attack would be against Kabul. I immediately summoned my begs to my court and held discussions with them. There was no question that Shyabani was powerful. I could not fight his army, nor was there any chance of a truce. It was appalling to admit that the only way out was to leave Kabul and attempt to establish myself somewhere else. I had two choices, to go to either Badakhshan or Hindustan. Eventually, it was decided that I would go to Hindustan.

I set out on my journey to Hindustan. It took me through the mountains, and among

the various tribes on the route were the terrible Afghans. Even in times of peace they would lie in wait for the moment when they could rob people. They had come to know about my journey to Hindustan, and at the first opportunity blocked our passage and charged at us with their swords. Although my army successfully defeated the Afghans and captured many of them, the number of these attacks put me off making the journey to Hindustan. With nowhere else to go, we camped on the nearby hills.

Meanwhile, I received news that Shyabani had retreated from Kandahar. Though Kandahar had not fallen to Shyabani, it was not under my control either. In the circumstances, I had little interest in attacking Kandahar again anytime soon. I then returned to Kabul.

The next year, on a splendid sunny day, my wife went into labour. She was in a room with the doctor and maids while I frantically paced outside. I prayed to God to keep my wife and child safe. Suddenly, I heard the baby cry. I was happy as well as nervous when one of the maids opened the door and emerged with my new baby son wrapped in a blanket. I held him in my arms and looked at him. The experience was like nothing I had been through before. It was a mixture of many emotions. I was scared, surprised, happy and speechless. At once, I fell in love with my son. I wanted to capture that moment in time and safely lock it deep in my heart.

How happy my mother and grandmother would have been! I missed my father terribly, too, thinking how I could have learnt from him

how to raise a son. It could be because of the absence of a father in my life that, as a young boy, I looked up to other male figures to learn how to behave and survive in the world. Then again, perhaps each father has his own journey and fatherhood would come to me naturally.

We named my son Humayun, meaning 'the fortunate one'. I wished for him to grow up to be a good human being – to be strong but sensitive, kind and educated. This was the balance I had tried to maintain throughout my life, despite the violence and temptation that surrounded me.

To celebrate my son's birth, I threw an extraordinary party. The tables overflowed with food and wine that had been specially brought from Bukhara. The best musicians were summoned from the furthest reaches of my

empire and dancers swayed to the music. People watched in awe and children clapped in delight as a magician turned a silk scarf into a pigeon. Begs great and small attended the feast. They brought valuable gifts and silver coins. No one had ever seen so many silver coins piled up in one place. I made sure the entire city was lit up at night and that no house went without food that day.

I watched the sky light up with stars and the city glisten with lights. I was a mighty emperor. I had my loving wife and my son with me. I was

in Kabul, the most wondrous place on earth. Life was idyllic. What more could I ask for? What more could life have in store for me? I knew that no matter how tough life becomes, if one can stay strong through those hard times there is much to look forward to.

I was on the threshold of a new chapter of my life.

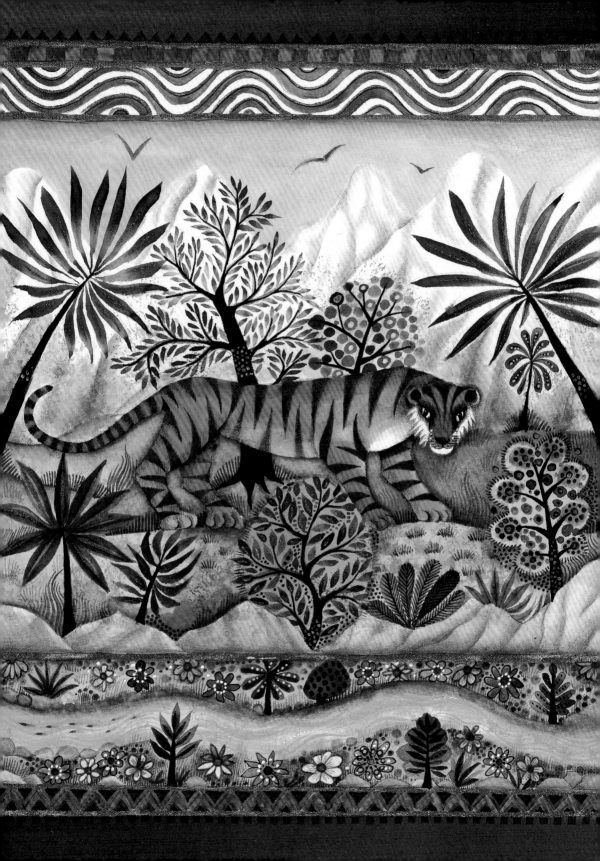

LIVING WISELY, RULING WISELY

One such decision was to extend my territory
beyond Transoxiana. For the next eleven years
I concentrated my time and effort on arming
and training my men for larger-scale invasions.
Though it seemed a period of calm, in fact it was
the calm before the storm. From an early age I
had held a keen desire to make my expedition
into Hindustan. However, there had always

been something preventing me from launching a military operation into that cherished land. Now, the moment had finally come.

I received the news of Shyabani's death. He had been killed by Shah Ismail, the Persian king. Shyabani had been the biggest threat to my rule. Though I had fought him I had waited for the day when I would defeat him in war. Therefore, the news of his death disappointed me as I was not to have had the satisfaction of defeating him.

Beyond this, I had been fascinated by his journey. He had started as a warrior leading the army of my uncle Sultan Ahmed Mirza during his rule in Samarkand, but eventually he drove out the Timurids from that fine city. Many a time I had failed miserably in my attempts

to reclaim Ferghana and Samarkand from
Shyabani. He went on to capture Bukhara and
Herat and planned on taking Kabul next. He
was fast becoming the most powerful man in
Transoxiana. Perhaps this was to be expected
– Shyabani too was a descendant of the great
Genghis Khan. The blood that ran through my
veins was the same as his. I had wanted to defeat
him not because he was weak but because
he was strong. Shyabani had proven that we
should never underestimate the power of our
enemy. I respected him for his bravery. Though
he always defeated me, I am proud that I had
fought a man of his greatness.

While Shyabani was alive, I was so busy
planning and preparing to fight him that I
had no time to capture or rule any city beyond
Kabul and Ghazni. Now, after his death, I

decided to forget my idea of regaining the lost cities and instead concentrate on new opportunities beyond the Hindu Kush region. First, I had to fight the various mountain tribes that lived in the region.

The two major tribes I had to control were from Bajaur and Bhera. These regions were situated next to the Hindu Kush region. The tribes had been living around Kabul for generations and were in the habit of robbing and stealing. My great-grandfathers had failed to control them, and I knew I could not change that. Thus, I decided it would be best for me to make an alliance with the tribe. Eventually, we came to a final truce.

Bhera was close to Hindustan, so I thought it was the best time for me to take control of the region. From there I could cross the River

Jhelum and attack Hindustan. As my army moved forward, I sent regular messages to the people of Bhera. I mentioned not only my arrival but also my intention not to harm them in any way. As a result, by the time I reached Bhera most of the tribes there were already supportive of me. I met little resistance when I occupied the area.

While in Bhera, I sent my messenger to Hindustan but did not receive any positive reply. With no progress in my expedition to Hindustan, I decided to return to Kabul.

On my way back to Kabul, we pitched camp several times to rest. In the afternoon, I went out to the fields near the riverbank and became drunk after drinking wine. Before my eyes, I saw an entire field covered with blooming purple and yellow flowers. I sat there for hours

watching the resplendent flowers. When I was sober again, I went back to the camp. On my way, I saw a tiger. I stopped in my tracks as the tiger looked me in the eyes and growled. Sikandar kicked up his hind legs and hurled himself into a nearby wood. The commotion made the tiger turn around and leap back into the forest. I tried looking for it without success. Thinking about it in hindsight, I am not sure

whether I saw a tiger or an illusion, created under the influence of alcohol.

After a long and tiring journey, we finally arrived in Kabul. I rushed to meet my wife and my son Humayun. I had been away from home for nearly a year, and when I finally saw Humayun, I was startled by how big and chubby he had grown. He looked at me with his big bright eyes and smiled. My tiredness melted

away immediately. Humayun would look around curiously and respond to the faintest of sounds. I enjoyed every moment I spent with him.

The journey from Kabul to Bhera and back to Kabul had taken a heavy toll on my soldiers and begs. One of my bravest and most loyal commanders came down with fever and passed away. His death left me terribly saddened. Wars always seemed to result in losses, rather than gains.

I asked myself, 'How many more brave warriors am I going to lose?'

Soon after, I too went down with a fever.

'Is it my turn next?' I wondered as I lay drenched in sweat, unable to eat or drink.

The doctor gave me wine laced with herbs but it didn't help. I remembered the time,

in Samarkand, when I had been in a similar situation. It had cost me two kingdoms. The thought revived my spirits and spurred me to fight the fever. Many begs and high-ranking officers came to visit and pay homage to me. They brought gifts with them but, strangely, none of these presents interested me.

'What am I to do with these gifts when I cannot sit up in bed?' I thought.

Nevertheless, the company of those visitors helped me get better. It made me feel cared for. I wanted to get well for the sake of my people, my wife and my dear son Humayun.

Miraculously, my health slowly improved, although I remained quite weak. I started attending parties. The alcohol did not do me any good and I kept away from it. I spent the next months fighting against various tribes

in different regions. I noticed that I was not as suited to battle as before. My exposure to hardship from an early age had affected my health. When unwell and not away fighting, I would spend my time with Humayun. He was growing up quickly and kept me on my toes. I could imagine going hunting and fishing with him. I wanted to teach him the skills a soldier needs. I wished I could take him to Ferghana for a few days and show him the place where my life's journey had started. I wanted him to meet his cousins and to ride Sikandar. Most importantly, I wanted him to enjoy life. For that to happen, I had to keep myself healthy. The father in me promised to give up drinking and to stay healthy for my son.

'Ah, the love we feel for our children! It can make you achieve the impossible,' I thought.

At the age of forty, the warrior in me geared up once again. I turned my attention to extending my empire from Transoxiana to the Hindu Kush mountains across to Hindustan.

8

HINDUSTAN AT LAST

Eighteen years have passed since the birth of my son Humayun. He is now a handsome young man. I have spared no effort in preparing him to be a worthy prince. He has received the education and training that is suitable for his rank. Above all, I have taught him to be kind and forgiving. I want him to value blood relationships and stay united with his family.

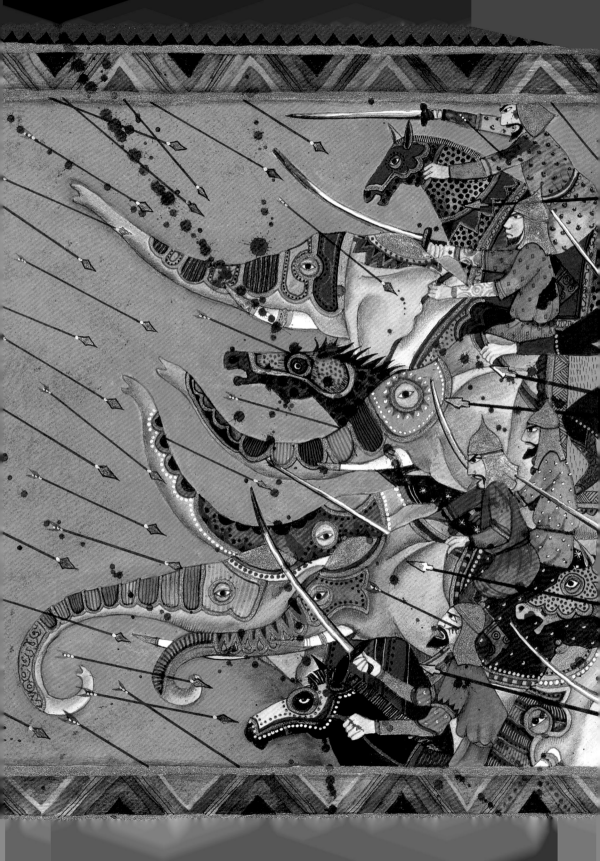

Unlike the struggles I had to go through in my lifetime, I want Humayun to lead a happy and enjoyable life. Sikandar is not as agile as he used to be, although he remains my dearest friend, and occasionally we go wandering in the nearby forests and meadows to spend time with nature. As soon as we are in the quiet of the forest, he either dozes off or chews grass while I write poetry sitting under a big tree.

I have never let go of my dream of launching an all-out attack on Hindustan. Soon, I would be fighting Ibrahim Lodi at the battle of Panipat, with Humayun, my lucky charm, by my side. The result of the battle changed the course of history for Hindustan. It would forever be known as the battle that laid the foundation of the Mughal Empire.

As with Transoxiana, Hindustan was divided into many states, each one ruled by different lords who fought for power. Two powerful dynasties ruled northern Hindustan. I fought against the dynasty of Ibrahim Lodi first. He was of Afghan descent and was the sultan of Delhi. He was without doubt a brave warrior. Among Ibrahim Lodi's many enemies was his uncle Daulat Khan Lodi. He considered himself to be the rightful heir to the throne but had to remain satisfied as a governor of Punjab. Blinded by humiliation and anger, Daulat Khan Lodi sent me messages asking me to help him fight against Ibrahim Lodi and drive Ibrahim from the throne.

This was a golden opportunity for me for two reasons. The first reason was my long-standing desire to make an attack into

Hindustan. My great-great-great-grandfather Timur had been successful in extending his territory to Punjab during his lifetime. And it had always been my dream to conquer it back and include it in my territory.

The other reason was that money was in short supply, despite my successful defeat and looting of the nearby mountain tribes. This made it difficult for me to maintain a large army. I had heard stories about the vast wealth of Hindustan and hoped to bring those riches to Kabul. Since internal arguments weaken kingdoms and make them easy prey, I felt optimistic. Experience had taught me that when family members turn on one another this presents an opportunity for an outsider. It would have been foolish of me to refuse Daulat Khan Lodi's invitation and miss my chance. I immediately set out for Hindustan.

The first thing I remember of Hindustan was the scorching, sweltering weather that hit me as soon as I crossed the Hindu Kush. We had to wait for Humayun and his army to arrive from Kabul before we proceeded any further. So I instructed my men to construct a garden near a place called Ningnahar and named it Bagh-i-Wafa.

During my stay there, I explored this astonishing new world. Everything about Hindustan was different from what I was used to. Once I arrived there, I found out that elephants really existed. In fact, they were everywhere. That those huge beasts could be tamed amazed me. For the Hindustanis, the elephant had the same function as the horse did for us. The elephants ate a lot, and they used their trunks to eat and to drink. Now I

knew the elephant was not a myth, I wondered if the Koh-i-noor diamond existed. Only time would tell.

Another large animal we saw was the rhinoceros. Though smaller in size than the elephant, this beast could not be tamed. They were found in the forests near the riverbanks, and someone told me a rhinoceros could lift an elephant with its horn. Just before lunch one day, while out hunting, I saw a rhinoceros face to face with an elephant. When the elephant

moved forward to charge, the rhinoceros ran away into the forest. That is when I knew for sure a rhinoceros could not fight an elephant, let alone lift one! Near the riverbanks we came upon alligators and crocodiles, which looked like big lizards.

Once Humayun and his men arrived, we set out with my army to Punjab. I captured Lahore, the capital, and became the king of Punjab. I divided other parts of Punjab among Daulat Khan and his sons. Daulat Khan was upset that

he had now lost his power over Lahore, too. I stationed small parts of my army in Lahore and a couple of other places in the region and returned to Kabul. Soon after I left, Daulat Khan regained his control over Lahore.

A year later, I returned to Hindustan with greater purpose and a larger army. Humayun, my blessed son, joined me on this expedition too, which boosted my morale. When I reached Hindustan, my troops stationed in Lahore and elsewhere joined me, and my army grew bigger. Daulat Khan immediately surrendered, nevertheless I could never trust him again. I sent him as a prisoner to Bhera, but he died on the way. Ibrahim Lodi's other uncle joined me, as did several of Lodi's men, who sent secret messages stating they would like to join me. By now, Ibrahim Lodi recognised there was no

alternative except to wage a war against me. The battle would take place in Panipat.

Early morning on the day of battle, I was getting ready when Humayun came to receive my blessings, as he always did before going to fight. He looked handsome in his armour, helmet, shield and spear. I blessed him with a kiss on his forehead. We exchanged a few words and he left for the battleground.

Finally, I was face to face with Ibrahim Lodi. Lodi's army consisted of well-armed infantry and cavalrymen commanded by experienced fighters on elephants. He had positioned the commanders and other high-ranking officers who rode the elephants in the first rows, to be followed by cavalry and infantry in successive rows. My army consisted of Turk, Mongol, Persian and Afghan soldiers. They had fought

many battles and were experienced warriors.
I knew Lodi's 100,000 soldiers and 1,000 war
elephants outnumbered us – in comparison,
my soldiers numbered around 15,000. The
situation appeared impossible, but I knew war
was not a game of numbers. Proper planning
and tactics were crucial. I had two main
strategies in mind for this battle. They were
tulguhma and *araba*.

Tulguhma meant dividing the whole army
into various sections of right, left and centre.
I secured the right and left sides with soldiers.
The other tactic was the use of *araba* or carts.
I had ordered my men to bring carts. There
were 700 altogether placed in a central forward
position, directly facing the enemy. I made
the soldiers tie the carts together with ropes,
leaving wide gaps between them. Cannons

were placed in those gaps. These cannons, when used, would form a wall of fire. Behind the carts were infantrymen who carried rifles, backed with archers behind them. I was at the centre rear, surrounded by my guards. At a first glance, the formation of my army looked as if it was designed solely to defend. On the left flank, by the River Yamuna, I made my men dig a deep trench and cover it up with tree branches.

I had put a lot of effort into planning my strategy. There was a huge risk involved, as I had never tried this type of strategy before. As Ibrahim and my own army prepared for battle, I turned towards Humayun. I wondered if he would show any sign of doubt about the result of this battle. He looked calm and I could see the determination in his eyes. He looked at me

and smiled. I smiled back at him and bellowed our war-cry.

Ibrahim's army surged forward to attack us. As they drew closer, they were in for a big surprise. I ordered the cannons to be fired and the land of Hindustan boomed with a deafening sound never heard before. The ear-piercing explosion baffled Lodi's elephants and they began trumpeting and charging in every direction. With the elephants going crazy due to the sounds of gunfire, the discipline of Lodi's army collapsed. In the confusion, the elephants trampled on many of Ibrahim's soldiers, and so they lay dead on the ground.

The soldiers who tried to attack us from the left side fell into the ditches. My cavalry surrounded Ibrahim's army on both sides while my archers fired volleys of arrows at

them. Ibrahim's army had never faced firearms and they had no cannons. Unfortunately for Ibrahim, many of his generals had secretly sent me messages earlier. They changed sides at the battleground and deserted him to join my army.

While Lodi's army was in a state of complete chaos, I joined the attack by moving around the carts and coming to the front. Ibrahim, too, moved forward. With his army in complete disarray, he was without any guards to protect him. Unable to hold out for long, he died in the battle. With that, Ibrahim Lodi became the last sultan of the Lodi dynasty.

I immediately sent Humayun to go to Agra and prepare a list of the treasure

that he could lay his hands on there. I seized the throne of Delhi.

The day I entered Delhi as its ruler reminded me of my first triumphant entry into Samarkand. That moment would have made not just my father but my great-great-great-grandfather Timur so proud of me. Once in Delhi, I went around sightseeing. I understood that, after crossing into Hindustan, I had only been in the company of soldiers and had not had an opportunity to meet civilians. I was in for a shock: the men were almost naked, wearing only a loin cloth, while the women wore a single, long piece of cloth draped around their body. A part of the cloth covered their heads while the rest concealed the remaining parts of the body.

Another thing that surprised me greatly was the monkeys. They could be seen jumping from

one house to the other and scurrying around the streets in family groups. The Hindustanis called them *bandar*. Back in Kabul, I had seen these monkeys during special occasions. I remembered the time when I had hosted the celebration at Humayun's birth and the performers had brought monkeys with them. I, along with the guests, had enjoyed watching the monkeys do many tricks. I had seen monkeys in the mountainous regions near Kabul, however, I saw one type of monkey for the first time in Hindustan. It was called the *langur*. This *langur* was larger than other monkeys and had a jet-black face and a long tail.

Though Delhi was the historic capital of Hindustan, during his rule Ibrahim Lodi had moved his official base from Delhi to Agra. His mother was still in Agra taking shelter when

Humayun took control of the city. Humayun's men had seized her, but Humayun showed her mercy and allowed her to move out of the fortress.

Once I reached Agra, Humayun showed me the treasure that had been left behind by Lodi. The enormity of the riches was mind-blowing. What we had won was no small feat.

Still, a greater surprise awaited me in Agra. Humayun told me that when he had reached Agra, his men had seized the family of the rajah of Gwalior who were fleeing the city. The rajah had joined Ibrahim Lodi in the battle of Panipat and he too had died in the battle.

However, when Humayun forgave his family, they presented him with many jewels to show their gratitude. As he told the story, Humayun took out a velvet pouch from his pocket and from the pouch he produced a magnificent, glistening diamond. I immediately recognised it. My hands shook as I held the biggest diamond in the world, the Koh-i-noor. Rumour had it that the total worth of the diamond could feed the entire world for two and a half days. I gave the diamond back to Humayun as he was now its rightful owner. He had earned it by his mercy towards Ibrahim Lodi's mother and the family of the rajah

of Gwalior. I was so proud of my son. A few days later, I organised a great party to reward Humayun along with the other begs and warriors for their display of bravery.

The next days were spent handing out the treasure. The wonderful system of measurements and numbering that the people of Hindustan had created made it easy. We divided the wealth between those in Hindustan, as well as begs, soldiers and their relatives in Samarkand and other places. And even after giving out so much treasure, the wealth of Hindustan was hardly reduced at all.

During my stay in Agra, I noticed Hindustan lacked the attractions of Samarkand and Kabul. Despite it being located on flat land, and boasting many rivers, there was a great lack of drinking water. I had been a witness

to Hindustan's artistry and skill when I was
in Samarkand. How strange to see there were
no monuments in Hindustan that remotely
rivalled those of Samarkand.

After exploring various places, I chose a place
near the Jamuna River to create a garden. With
time, this garden was full of splendid trees laden
with fruits, and birds of various kinds could
be seen. I enjoyed listening to the cuckoo, the
nightingale of Hindustan. The
beauty of the gardens was made
even greater by the presence of a
magnificent colourful bird called
a peacock, known in Hindustan
as a *mayur*. One creature I had
never seen before was strange indeed – a bat.
The Hindustanis called it a *chamdagar*. It was
as large as an owl and its head looked like a

puppy. The strangest thing about the bat was that it grabbed a branch of a tree and hung upside down. In the time that followed, amid these weird and wonderful plants and animals, I continued to build gardens, baths, wells and mosques in and around Agra.

The year in Hindustan was divided into three seasons, each of four months. Summer was extremely hot in Agra. During summertime, I ate an unbelievably ugly and foul-tasting fruit called the jackfruit. When cut open, the huge sticky fruit looked like a sheep's intestines turned inside out. The best thing about summer in Hindustan were the ripe mangoes. The Hindustanis glorified the mango as the king of the fruits, and rightly so. Mangoes are green when unripe and then turn a fabulous, blazing orange and yellow when they ripen. When I

tasted one for the first time, delicious flavour exploded in my mouth.

Nonetheless, mangoes were not enough to keep the soldiers happy in a foreign land. The heat became unbearable for them, and many fell sick – some lost their lives. My men were used to raiding a region and then returning to Kabul laden with loot. They could not understand why we remained in Hindustan, especially now we had so much treasure in our hands. I did not blame them. How could they possibly know how a ruler thinks? I had longed to conquer Hindustan from an early age. Over a period of seven or eight years, I had led my army to Hindustan five times. Finally, on the fifth attempt, I had managed to defeat Ibrahim Lodi and occupy his throne. My territory now expanded from Kabul to northern Hindustan.

My successes would have never been possible without God's blessing and the support of my army. Be that as it may, the long-distance travel, bad weather conditions and homesickness slowly took a toll on the patience and morale of my army. We had struggled together for many years and defeated many enemies.

At that point, we had two choices. The first was to return to Kabul and live off the wealth we had looted. But how long would the money last and what would we do when it ran out? Go back to our old life of looting nearby mountain tribes? The second option was to continue to conquer and become the most powerful army in the land. My forces were the key to my success and a means to achieve my dreams. And my success meant their success. As always, my men listened to me and remained loyal. They

understood that as soldiers it was their duty to follow their leader. The heat of Hindustan would not deter my ambition, and I decided to stay in Agra.

Just when I thought I had conquered all, I had to face my next enemy in northern Hindustan – the Hindu Rajput ruler of Mewar, Rana Sanga.

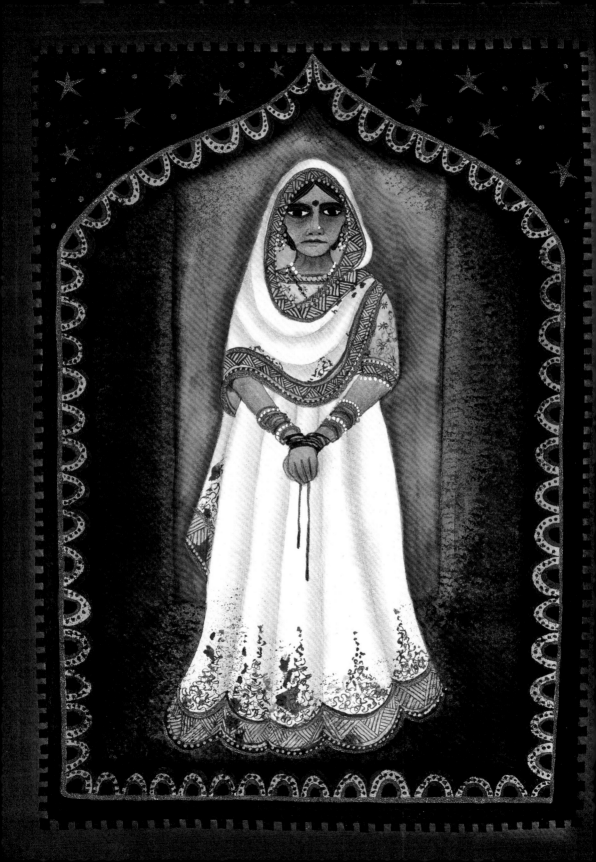

The Life of a Ruler

Every time I go into battle, I mentally prepare myself to die. I am aware that the result will be either my death or my enemy's. Fighting in the field is the height of danger. But for a warrior like me, it is the most respectable way to die. People generally believe the battlefield is where a king's life is most at risk. But it was within the four walls of my fortress, where my

loyal guards surrounded me, that I came close to losing my life.

My victory over Delhi and Agra filled me with great satisfaction. I had now reconquered the former territories of the Timurid Empire. My soldiers, their pockets bulging with riches they had never seen before, were impatient to go home and join their families.

However, they failed to understand that unlike in the past, this time I was not here to loot. I was here to make Hindustan my permanent home. My desire to expand my territory as far as Samarkand fulfilled my father's dream. And taking over Punjab meant regaining the territory my great-great-great-grandfather had once conquered. I now wished to expand my territory further. But for that, I

would first have to defeat two of the bravest warriors in of Hindustan and clear the way ahead, as it is impossible for two swords to fit in one sheath.

Five Muslim and two Hindu rulers ruled Hindustani. Ibrahim Lodi – who was now out of my way – controlled the north, along with Rana Sanga, the Rajput rajah of Mewar. Rana Sanga was believed to have fought and won a hundred battles, and it was said that no one in Hindustan could defeat him. Sanga was trying to unite several Rajput kings and establish his empire in Hindustan. He was slowly advancing towards Delhi and Agra. If he conquered those two places, he would be the undisputed emperor of northern Hindustan. After the death of Lodi, I stood in his way. He was not ready to accept me as the *padishah* of Delhi.

I understood well it would not be possible for me
to rule Hindustan while Rana Sanga was alive.

Sanga busied himself with uniting the
Rajput kings and teamed up with the Afghans
who ruled eastern Hindustan at the time.
Meanwhile I conquered the strong forts on
the border with Agra. These regions had
been under Rana Sanga's rule, and my control
over them angered him even more – he was
desperate to fight me and win his territory back.

While I prepared myself for my encounter
with Sanga on the battlefield, I was unaware of

the plotting and scheming that was under way within the walls of the fortress.

After coming to Hindustan, I was introduced to new delicacies each day. Out of curiosity and love for the cooking of Hindustan, I had kept four of Ibrahim Lodi's cooks for my kitchen. They cooked Hindustani dishes and would sometimes mix Mughal delicacies with Hindustani spices. The style with which they prepared mouth-watering meals in decorative gold and silver bowls made of semi-precious stones showed their good

taste. One of those days, as usual after my prayers, I sat down to eat. I particularly enjoyed the rabbit stew and a Hindustani dry meat delicacy with saffron dressing.

No sooner had I eaten than my stomach churned, my heart rate rose, and I felt sick. I ran from my dining room and fell violently ill. The cook was summoned, and it did not take long for him to confess. To my utter surprise, Ibrahim Lodi's mother, Dilawar Begum, had put together a plan to poison my food. She wanted to murder me and was waiting for the right moment to do so. She had started scheming from the day Ibrahim Lodi had died.

With the help of one of the food tasters, she had smuggled poison into my kitchen. Working secretly with one of the cooks, she put her plan into action. At the last moment, the food taster

feared being caught, panicked, and emptied a tiny amount of poison into my food. He and the cook were executed for their crime. Dilawar Begum, on the other hand, was immediately imprisoned.

I will never forget the look on Dilawar Begum's face as her punishment was read out to her. She stood before me with dignity and her eyes bore no sign of guilt or shame. In fact, they betrayed a hint of disappointment to see me alive. I saw in her a wounded mother who would go to any lengths to avenge her son's death.

It took me a few days to recover. I took doses of a specially prepared mixture that succeeded in driving the poison out of my body. Once restored to good health, I resumed my preparations to fight against Rana Sanga.

Finally, we faced each other at the battle of Khanwa. My strategy for the battle was the same as for Panipat. But this battle lasted twice as long as Panipat and ended with heavy losses on both sides. Rana Sanga lived up to his reputation as a great strategist and warrior. He fought bravely and at one point the battle turned in his favour. My men almost gave up in fear and I had to speak to them to raise their morale.

Sanga had made many alliances and had a huge army. It was no mean task for him to have brought the Rajputs and the Afghans together for this battle. No matter how big the army, coordination and discipline are the key factors in a war. Rana Sanga was brave yet he lacked skills in organising his men. Fired with anger, he marched ahead, fierce and unprotected. As

soon as he was out in the open, arrows rained
on him. One arrow hit him, and he fell from
his elephant. I galloped towards him
to plunge my sword into his chest.
However, before I could reach
him, his men quickly
carried him off to safety.

Later, I learnt he was
back on his feet and had
pledged to his people that
he would never return to Mewar until he had
defeated me and conquered Delhi. But his
words failed to inspire his men. They had
perhaps recognised it was hopeless to fight
against me. They tried to talk him out of his
plan. When Sanga refused to compromise,
one of his men poisoned him. A terrible end
for one of the bravest warriors the world had

ever seen. With the death of Ibrahim Lodi and Rana Sanga, I became the undisputed emperor of northern Hindustan. I received the title of *ghaji*, the supreme king.

Humayun had long wanted to return to Kabul, and I promised him that he could go home after the battle of Khanwa. He had fought bravely at the battles of Panipat and Khanwa and had earned the right to see his homeland again.

Similarly, my army had suffered terribly. After their extraordinary efforts in the battle, they deserved to be allowed to return to Kabul. It would not have been a wise idea to test their endurance any further. I said farewell to Humayun with a heavy heart although I was glad he would be happier at home in Kabul with the rest of the family. After Humayun had

left, I travelled around my new territories and constructed gardens and wells in the region. I fought in battles from time to time. Despite this, my health deteriorated, and I could not sleep at night. During such times, I escaped my troubles by writing poems.

~10~

SETTLEMENT OF THE EAST

I am Zahir ud-Din Muhammad Babur, the
founder and first emperor of the Mughal dynasty.
My dynasty will rule Hindustan for centuries. I
have lived my entire life with the fear of losing my
power. In search of power, I have come close to losing
my life several times. Nevertheless, my will has won
out over my fears. I am now the emperor of northern
Hindustan, and Agra is the new centre of my power.

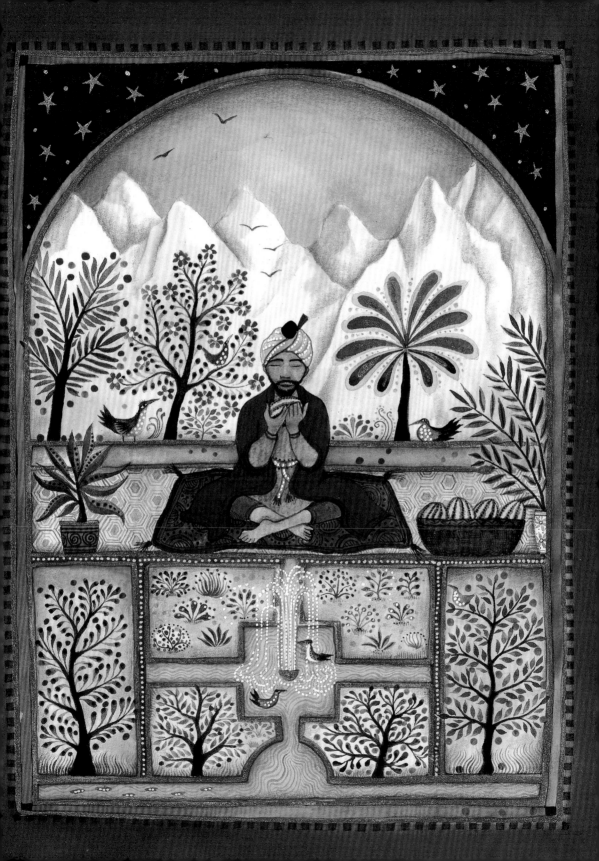

What a journey it has been! And the journey within has been tougher. Life has brought me victories and defeats, love and betrayal, greatness and poverty. I often wonder if it was worth it. And the answer, I think, is yes. I am who I am today because of my experiences. With what I have achieved, you would think there was nothing left for me to desire. However, desires are never-ending. My one wish now is to go to Kabul. I miss Kabul like the deserts miss the rain.

I believed my position was completely safe in northern Hindustan. However, the year after my victory at Khanwa, I had to face Medini Rai in the battle of Chanderi. Chanderi had once been ruled by Ibrahim Lodi, although Rana Sanga had taken it during his lifetime. After Rana Sanga's death, Medini Rai was its ruler.

He was loyal to Sanga and had helped him at the battle of Khanwa. After Sanga's death, I had tried my best to persuade him into joining my army, yet he refused. In the end, he was fated to die in the battle of Chanderi. After the deaths of Ibrahim Lodi and Rana Sanga, other rulers schemed against me, but they were easily crushed. There was no one left in northern Hindustan who could challenge me.

It had been a long time since my men or I had any time to relax and enjoy ourselves. So the victory over Chanderi was the perfect reason for a grand celebration. I invited kings, princes, begs, noblemen, warlords, merchants and high-ranking officials from within and outside Hindustan.

The feast was held in a huge hall. The seating plan was organised according to the ranks and

positions of the visitors. A large hand-woven cotton carpet, made in Agra, was spread in front of where I would be seated.

On the day of the feast, I was thrilled to see guests arriving from places as far as Samarkand to join the celebration. Among the guests, many claimed to be descendants from both my great-great-great-grandfathers' sides. The guests were dressed in fine, vibrantly coloured robes of velvet and silk, studded with precious stones and embroidered with gold thread.

The guests brought their gifts and placed them on the carpet in front of me. A pile of gold and silver coins gradually grew higher, along with another pile of gifts next to it. The guests presented their gifts as a greeting, then joined the celebrations taking place around the great hall.

There was singing and dancing. A magician performed tricks by blowing flames out of his mouth. Monkeys were made to perform stunts, and there were fireworks everywhere.

Soon, a lavish dinner was served to the guests. There were Mughal and Hindustani delicacies along with the finest wines from Bukhara.

After the food was served, Hindustani acrobats entertained the guests by performing extraordinary feats. I had seen nothing

like it in my entire life and, I am sure, neither had most of my guests. The performers stood on their heads, balanced on tightropes, did somersaults and walked on stilts. This jaw-dropping performance was followed by

wrestlers fighting at a short distance from the hall, out on the open ground.

The huge banquet lasted throughout the night. As it grew darker and the crowd became bigger and boisterous, I felt lonelier than ever. When you are powerful you are surrounded by people, but it is important to know who your real friends are. They are the ones who stay with you through your ups and downs in life and not only when you are rich and successful. Or, as with my dear Sikandar, now grazing peacefully in the pastures around Kabul, they had no interest in human affairs. I had been deceived in the past, but experience had made me wiser. That evening, then, though the very large number of guests made me happy, I was not deceived into thinking they were my friends.

The celebration was the talk of the town for a long time. I sent most of the gifts to Kabul.

While I got to know the culture and way of life of northern Hindustan, the south stood firm. Unlike the north, the south was united under one of the greatest emperors of Hindustan, Krishnadevaraya. He had successfully resisted Muslim invaders who had attempted to attack the empire of Vijayanagar. Just as I had united the Timurid princes and built an empire, Krishnadevaraya had brought together the Hindu rajahs. Now he wanted to extend his empire to Delhi. I did not consider this the right moment to provoke him.

Instead, I turned my attention towards the east. The Afghans in the east were secretly scheming to overthrow me and were ready to rebel. Sanga's death had weakened their

morale, but I had not been able to crush them completely. Led by Mahmud Lodi, one of Ibrahim Lodi's brothers, they made another attack on Delhi. I decided to put an end to the Afghan threat once and for all. It did not turn out to be a difficult task, as they quickly surrendered before me. My final battle with Mahmud Lodi took place in Ghanghara and he died on the battlefield. I had now crushed the Afghans completely. The battle of Ghanghara would be my last battle in Hindustan.

Hindustan was my new home now, and I travelled around the different regions of the north of the country. Making the best use of what was available in Hindustan, I tried to recreate the splendour of Kabul in Agra. I constructed gardens in every palace and province, and I sent for fruit and rice saplings

from Kabul and taught the gardeners to grow them. Nevertheless, regardless of how dazzling these gardens and orchards were, they were no match for those of Kabul.

When one of the gardeners brought back melons from Kabul and offered them to me, I held one carefully with my hands and closed my eyes as I inhaled the aroma of the fruit. Nostalgia for my family, my land and my younger days made my eyes fill with tears.

As ever, I wrote a good deal of poetry – a passion that will never leave me. I also wrote letters whenever I wanted to express myself directly. I wrote to Humayun in Kabul. These letters, in many ways, were like the conversations I would have liked to have if he were with me. I would usually start off by updating him on what was happening here.

Then I moved on to giving him advice about how to treat his brothers, particularly to be forgiving. As any father would have done, I pointed out his mistakes, even small ones such as bad spellings in his letters. I told him to check what he had written before sending his letters to me. I would end by asking him to bring the rest of the family to Hindustan.

Sometimes in his letters Humayun would express feelings of loneliness. I would immediately reply, reminding him that as a royal prince he could not afford to let this get the better of him. As a future king he should be aware of what his duties and responsibilities were. It was easy to advise Humayun not to let the feeling of loneliness occupy his mind. The truth was that I could not follow my own advice and I myself felt terribly lonely.

When Humayun came back to Agra, I was overjoyed. He brought with him the delightful news of his son's birth in Kabul. I had become a grandfather. And it was more exciting to think that Humayun was now a father. Though I had not seen my grandson, I already felt so much love towards the new arrival. The next months were the happiest time of my life.

Not long after his return to Agra, Humayun fell ill, which threw me into a state of deep distress. Despite the efforts of the best doctors tending to Humayun, he showed no sign of improvement. They had almost given up hope of his recovery. I would spend my time at his bedside, watching him as he lay unconscious. I would hold his hand, caress his head and circle around his bed praying to God for his speedy recovery. My achievements seemed worth

nothing as I helplessly prayed for my son's life. I told God I was ready to exchange my life for my son's and begged Him to take my life but save my son. Miraculously, Humayun's condition started to improve, and soon he was back on his feet. People say there is nothing worse in the world than the fear for your own life. Once you have children that situation is different. Nothing is more valuable to you than your child's life, not even your own.

After Humayun's recovery, my own health began to rapidly get worse. I felt exhausted all the time. It must have been the strain of continuous warfare, the hard life I had led, and the poison that had got inside my body and nearly finished me off. While still a boy, I conducted myself like a grown-up, far beyond my years, and I felt I was a man. And now, at

the age of forty-seven, I felt like an old man. I wished I could have lived according to my age and had not had to grow up so fast.

I often wonder how I will be remembered.
Will people think of me as a great warrior or
as a cruel tyrant? I leave that for you to decide.
I have tried to live and rule as well as I can,
to show strength and mercy whenever I can.
I have perfected the arts of war and created
a mighty empire. But it is the gifts of peace –
poetry, music, food and drink, friendship, and
above all, family life, as a husband, father and
now grandfather – that have shown me how
to live well. In this respect a king or emperor

is no different from any man or woman from any background in life. Thank you for coming with me on my journey. I hope my story will help you to be strong and wise in everything you do. I hope it will help you to learn from my mistakes and to make better choices in life. Most importantly, I hope you will never forget to enjoy what life has to offer, and to be grateful for it. I lay down my pen here as I go to sleep and dream of my dear Sikandar and me galloping in the mountains of Kabul surrounded by tulips.

The End

GLOSSARY

Alliance – An agreement between countries or rulers to work together

Beg – Important official

Caravan – A group of travellers on a journey through deserts or hostile regions

Courtier – A person who attends a royal court as a companion or adviser to the king or queen

Descendants – Family members who come after someone in future generations

Dynasty – Rulers of a country belonging to the same family

Emperor – A king ruling many countries

Exile – Forced to leave one's own country, usually for political reasons

Fortress – A military stronghold, especially a strongly protected town

Invade/Invasion – Entry of an army into a country to occupy it

Madrasa – Arabic word for any type of educational organisation

Mirzas – Rank of a royal prince, nobleman, famous military commander or scholar

Observatory – A building for studying the stars

Ota – Father

Padishah – Emperor

Province – A part of a country with a government of its own

Raid – To enter a place and to steal

Rajah – Name for a king, prince or other ruler in India

Refuge – A place or situation providing safety or shelter

Shakhzade – Prince

Siege – A military operation in which enemy forces surround a town or building, cutting off supplies like food, with the aim of forcing people inside to surrender

Sultans – Name for Islamic rulers

Territory – An area of land under the control of a ruler or state

Trade route – A long-distance route along which goods, such as cloth and food, are transported to be bought and sold

Treaty/Truce – An agreement between two sides to stop fighting and live in peace

Note on the Text

The mighty prince Zahir ud-Din Muhammad, better known as Babur, founded the Mughal Dynasty that ruled India for hundreds of years. He wrote down his life story from 1494, when he was still a very young man, until his death in 1530. This book, written in a form of Turkish called Chagatay and then translated into Persian on his grandson Akbar's orders, was known as the *Baburnama*. Both versions became known to scholars, and for the last two hundred years the book has been translated into many languages, including English and Russian. For her retelling of the story, Anuradha has read English translations of Babur's Chagatay Turkish text. In her new version of the story, Babur speaks to us directly, first as a boy with huge responsibilities and later as a man who has learnt much on life's journey.

Acknowledgements

Thank you to Deputy Chairwoman HE Saida Mirziyoyeva for supporting this project from the outset.

Thanks also to Gayane Umerova for initiating this project on behalf of the Foundation.

Thank you to the partners and team members of the Arts and Culture Development Foundation of the Republic of Uzbekistan.

Thanks to my family for keeping me grounded and not giving a hoot when I walked around the house imperiously as a self-proclaimed international writer.

Thanks to everyone on the Scala team. Special thanks to my publisher Neil Titman for his absolute confidence in me as a writer and constant encouragement, and my ever-patient and helpful editor, Beth Holmes.

Thank you to Jane Ray for her stunningly beautiful illustrations, amazing designer Matthew Wilson and Martha Halford-Fumagalli for her excellent work on publicity.

Various activities of the Art and Culture Development Foundation of the Republic of Uzbekistan are aimed at the preservation of cultural heritage, the promotion of contemporary culture in Uzbekistan and the development of inclusive environments in the public sector. The ACDF actualises traditions and promotes innovation through an extensive programme of crossdisciplinary projects, research, architectural restoration, cultural exchange, international collaborations, exhibitions, concerts, performances and conferences among other initiatives.

To build upon its cultural programming, the Foundation has initiated a long-term collaboration with Scala Arts & Heritage Publishers. The strategic partnership will result in a series of publications, covering both academic scholarship and encyclopaedic guides, dedicated to the cultural heritage of Uzbekistan, its historic legacies and artistic achievements. Published in several languages, these books aim to introduce the vibrant culture of Uzbekistan to broad audiences and to expand available knowledge to readers across the world.

Copyright © 2022 Scala Arts & Heritage Publishers Ltd and the Art and Culture Development Foundation of the Republic of Uzbekistan

Special support: Saida Mirziyoyeva, Deputy Chairwoman of the Council of the Art and Culture Development Foundation of the Republic of Uzbekistan

Commissioning Editor: Gayane Umerova, Executive Director of the Art and Culture Development Foundation of the Republic of Uzbekistan

First published in 2022 by Scala Arts & Heritage Publishers Ltd, 305 Access House, 141–157 Acre Lane, London SW2 5UA
www.scalapublishers.com

Distributed in the book trade by ACC Art Books, Sandy Lane, Old Martlesham, Woodbridge, Suffolk IP12 4SD
accartbooks.com

ISBN 978 1 78551 394 7

Retold by Anuradha
Illustrations by Jane Ray
Designed by Matthew Wilson
Printed and bound in Turkey by Elma Basim

ART AND CULTURE
DEVELOPMENT FOUNDATION
OF THE REPUBLIC OF UZBEKISTAN